HOW TO cheat IN 3ds Max 2011

Get spectacular results fast

Michele Bousquet

Routledge
Taylor & Francis Group

LONDON AND NEW YORK

First published 2011 by Focal Press

This edition published 2015 by Focal Press

Published 2017 by Routledge
2 Park Square, Milton Park, Abingdon, Oxon OX14 4RN
711 Third Avenue, New York, NY 10017, USA

First issued in hardback 2017

Routledge is an imprint of the Taylor & Francis Group, an informa business

Library of Congress Cataloging-in-Publication Data
Bousquet, Michele, 1962-
 How to cheat in 3ds Max 2011 : get spectacular results fast / Michele Bousquet.
 p. cm.
 Includes bibliographical references and index.
 ISBN 978-0-240-81433-9
 1. Computer animation. 2. 3D studio. 3. Computer graphics. I. Title.

 TR897.7.B6838 2010
 006.6'96--dc22
 2010017975

British Library Cataloguing-in-Publication Data
A catalogue record for this book is available from the British Library.

ISBN 13: 978-1-138-40076-4 (hbk)
ISBN 13: 978-0-240-81433-9 (pbk)

Contents

Contents

How to cheat, and why

The truth about cheating

The word *cheat* has an interesting history. In its original meaning, it described the passing of an inheritance to someone other than one's heirs. This definition has come up through the ages to mean getting something dishonestly, or getting things by tricks or good luck.

In this book, you'll learn shortcuts to make 3ds Max do amazing things without having to learn it all from scratch, and thus make your own good luck as an artist. There are some very thick books out there that cover every possible tool in 3ds Max—in fact, I've written a few of them myself—but this is not one of them. If you want to get the job done in the least possible time, then this is the book for you.

The "cheats" in this book were all gleaned from real-world jobs and projects, where the client wanted something done in three days, not three months or even three weeks. I learned most of this through trial and error, and eventually developed my own bag of tricks. With this book, I've opened the bag and spilled out the contents.

Enjoy your inheritance.

Workthroughs and examples

Each workthrough in this book is designed as a double page spread. This allows you to prop the book up next to your monitor as you work with the files from the website. Many of the examples pertain to real-world companies, and show techniques used for a recent job.

In nearly every chapter is an Interlude with a discussion of a relevant topic. Think of it as advice from the shopworn.

What's on the website?

On the website shown below are starter scenes and maps for many of the cheats in this book. Feel free to try out the techniques on the included files, or use your own scenes instead. I've also included final scenes and animation so you can see the end result. The names of files that pertain to the cheat appear under the globe icon on the right page of the spread.

Download the file and its textures into the same folder on your hard disk. When you load a scene file for the first time, you might get a message telling you that 3ds Max can't find the maps. Just browse to the folder where you stored the maps and add the path to that folder, and all the maps for that chapter should load without further messages.

There are a few images and scenes that couldn't be included on the website due to copyright constraints. In most cases, you can visit the website of the company that provided the imagery and see plenty of their work there.

www.howtocheatin3dsmax2011.com

Acknowledgments

Although I'm no stranger to authoring, this book is a departure from my usual style. I am grateful to my Series Editor, Steve Caplin, for developing the Cheat Series and making it so easy to create such a lively book.

I had a wonderful team of people to assist me in creating this revision. Mark Gerhard, my technical editor and colleague from my Autodesk days, offered up invaluable insights based on his long career as both a 3ds Max user and instructor. Beau Perschall and Mike McCarthy, both longtime users of 3ds Max, provided useful input on new features and cheats for 3ds Max 2011. Proofreader Anne McGee cleaned it all up with her unflagging attention to spelling, grammar, and layout.

Many individuals and companies allowed me to include photos and samples of their work, and each of them are credited on the appropriate page. I am especially proud of my CGSociety.org students whose work is featured in the Appendix.

Of course, no book would exist without its editors. Laura Lewin at Elsevier somehow got me through the first edition of this book, and Katy Spencer got me to finish this revision in record time. I don't know how these amazing people put up with authors like me, but they do, and always with a smile. Thanks, guys.

Michele Bousquet

How to use this book

I'd be surprised if anyone read this book by starting at the beginning and going through to the end. This is the kind of book you should be able to just dip into and extract the information you need.

Still, I'd like to make a couple of recommendations. The Introduction chapter deals with the basics of using 3ds Max, so if you're new to the program, you should start there. In general, you can't do anything else until you do a bit of modeling, so I recommend that you look through the Modeling chapter before tackling some of the more advanced topics like character animation and parameter wiring.

Although the book is designed for users of 3ds Max 2011, most topics apply to 3ds Max 2010 and many apply to earlier versions as well. The .max files on the website are in 3ds Max 2010 or 2011 format, but all the bitmaps will work with any version.

The techniques in each chapter build up as you progress through the workthroughs. Frequently I'll use a technique that's been discussed in more detail earlier in the same chapter, so it might be worth going through the pages in each chapter in order, even if you don't do every cheat or read every chapter in the book. If a cheat mentions a topic you're not familiar with, check the Index or the 3ds Max help for more information.

The globe icon, when it appears on a tutorial page, indicates that file(s) listed below the icon are available on the website. These files are the same ones used to create the images for that topic. You can use these files immediately to try out the cheat, or use your own instead. The website URL is:

www.howtocheatin3dsmax2011.com

■ Using 3ds Max is an adventure that begins with a few important steps.

Introduction

THE TECHNIQUES DESCRIBED in this book assume a basic grasp of 3ds Max. But with so many options to choose from, it's easy to get lost in all the tools, buttons, and menus.

Not all features are created equal. This chapter goes over the fundamentals of 3ds Max with an eye toward the most important tools and how you can use them to create beautiful scenes as quickly as possible.

10.1016/B978-0-240-81433-9.50001-5

Making a scene

1 Before you load 3ds Max, gather up a few pictures with lighting, materials, and composition that approximate your vision of the final rendering. You won't be copying these images, but having them handy for reference will be invaluable as you create the scene.

THERE IS A MYTH that you should spend most of your time modeling, and then cram all the lighting, texturing, and animation into whatever time remains in the schedule. This so-called wisdom stems from the early 1990s when computer graphics were new, modeling was a rare skill, and any rendering at all was impressive.

Nowadays, clients expect decent materials, lighting, and animation, if not outright realism. To achieve this goal, the best approach is to take time at the front end to gather reference materials such as photos, drawings, videos, and textures. Each hour spent on preparation can reduce scene creation time by five or even ten times, in addition to providing a strong direction for modeling, materials, and lighting.

4 Gather up or create your textures and reference images. See the Modeling chapter to find out how to create reference images and textures from photographs and the Materials and Mapping chapter for creating tileable textures.

7 If animation is part of your scene, get a rough animation in place before working with lights and rendering. Test renderings and previews will give you a quick approximation of the final result. See the Animation chapter.

2 Sketch out the scene with all major elements. This step can be as elaborate as a color storyboard or as simple as a quick line drawing on a slip of paper. Even if you're using a detailed architectural plan, consider items that aren't noted such as trees, cars, and people.

3 In 3ds Max, block out the scene with primitives as placeholders for the final objects. This will enable you to place a camera and see which objects need to be the most detailed. You can also place a few representative lights to get an idea of how they'll work with the scene.

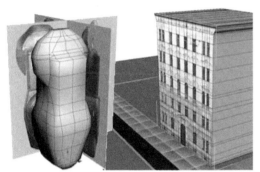

5 Now you can start modeling. Use the reference images and textures liberally to guide the process. The best tool for modeling is the Editable Poly. See the Modeling chapter for tips on speedy modeling using your maps.

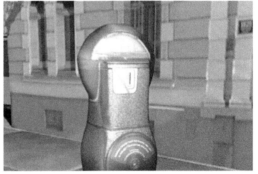

6 Materials and mapping are next. Avoid spending a lot of time tweaking colors and reflections as materials will change appearance when lighting is added or changed. See the Materials and Mapping chapter for tips on quick mapping.

HOT TIP

Photographs coupled with a bit of work in Photoshop can provide you with all the reference material you need.

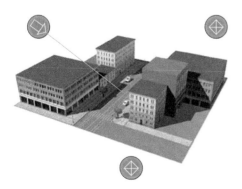

8 Place lights in the scene to simulate "real" lighting, such as near an indoor lamp or in the sky to simulate the sun. Shadows are a key element in adding dimension. See the Lighting and Shadow chapters for more details.

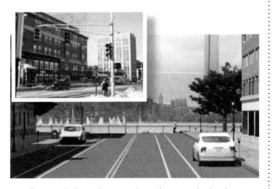

9 Test renderings show you how the scene is shaping up. This is the time to compare your rendering with sample photos and pick out details that will improve realism. See the Reflections and Rendering chapters.

A selection of selections

THE ABILITY TO SELECT objects at will is an important skill for working quickly with 3ds Max. Just about every operation you perform will start with the selection of one or more objects or sub-objects.

Conversely, there's nothing more frustrating than knowing exactly what you need to select, but not knowing how to select it or get at it.

Every possible type of selection can be done with the tools at hand. It's just a matter of knowing them so you can mix 'n' match when needed.

1 When you rest the cursor over an object's wireframe for a moment, the object's name appears as a tooltip. This is one reason why it's important to name your objects intelligently.

4 To select multiple objects, hold down *ctrl* while clicking. To unselect an object, hold down *alt* while clicking. These tools also work with bounding regions, described in the next step. In earlier versions of 3ds Max, holding down *ctrl* while clicking an already selected object used to unselect it.

7 To select multiple objects or select by name, click the Select by Name button on the toolbar or press the *H* shortcut key. On this dialog, you can display specific sets of objects such as just geometry or lights.

8 The Scene Explorer (Tools menu > Scene Explorer) is similar to the Select by Name dialog, but you can leave it open as a floater while you work. You can also open multiple Scene Explorers showing different sets of objects.

2 Click an object's wireframe to select it. In a wireframe view, you will need to click an actual line. The axis tripod appears, the object wireframe changes color, and the object name appears on the panel at the right of the screen.

3 If objects are on top of one another in the view you're working with, you can hold the cursor still and click multiple times to cycle through the objects. Watch for the object name to appear on the panel.

5 You can also select multiple objects by drawing a bounding region around them. Start by clicking in a blank area of the viewport, and then drag in any direction. The shape of the region is determined by the Selection Region currently chosen on the toolbar.

6 The Window/Crossing toggle on the toolbar determines how the bounding region works. When Window is turned on, only objects that are completely within the bounding region are selected. When Crossing is on, all objects touched by the bounding area are selected.

9 When the object is at a sub-object level, you can only select sub-objects that correspond to that level for that object. To select other objects, you will need to return to the base level of the object by exiting the sub-object level.

10 The Selection Filter can limit your selections to specific object types such as lights and cameras. Be sure to reset the selection to All or Geometry to select objects again.

HOT TIP

Pressing the space bar locks or unlocks the current selection. If you think you might have accidentally locked the selection by pressing the space bar inadvertently, look for the lock icon on the status bar to see if it's turned on. Just press the space bar to turn it off again.

Zoom, pan, display

O VER THE COURSE of your work with 3ds Max, you will need to zoom, pan, and rotate the scene many times to get the job done. You'll also need to switch your viewport displays between wireframe and shaded to see what's going on with the model. Learning how to use the tools available will save you a great deal of time in the long run.

A mouse with a middle wheel can speed up your work in 3ds Max by many times, allowing you to zoom, pan, and rotate the scene quickly and easily. This inexpensive investment will speed up your viewport navigation by many times.

3 The zoom controls are at the lower right of the screen. The Zoom Extents buttons are useful for getting objects back into view. The Maximize Viewport Toggle switches between smaller views and larger views.

2 To change a view to a different angle, use a hotkey (**F** for Front, **T** for Top, **L** for Left). To change to a perspective view, press the **P** key. You can also click the viewport label or press the **V** hotkey to choose from a menu.

5 If you have a middle mouse wheel, hold down *alt* and the wheel at the same time, and drag to rotate the view.

6 You can also use the View Cube to rotate the viewport or change to a different view. Click a view on the cube itself, or click a rotation arrow to rotate the view by 90 degrees. Drag any part of the cube display to change the view to a custom view. *ctrl* *alt* **V** toggles the View Cube on and off.

1 Use **F 3** to toggle wireframe and shaded displays in any viewport, and **F 4** to toggle edge display when in shaded mode.

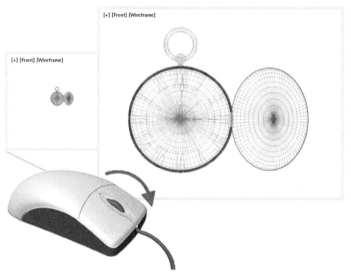

4 If your mouse has a middle wheel, you can zoom in and out by rolling the wheel, or pan by pressing the wheel and dragging. This method of viewport navigation means you don't have to keep clicking different viewport navigation buttons to move around your scene.

HOT TIPS

Pressing *ctrl* + Zoom Extents All zooms all viewports except the Perspective view. This is useful for keeping a Perspective view exactly as it is for rendering while zooming the remaining viewports.

If you like the view in a viewport and want to keep it to return to later, you can use Viewports menu > Save Active [current view]. Use Restore Active [current view] to get it back.

7 If you prefer a different viewport arrangement, use Views > Viewport Configuration > Layout tab to set them up differently. You can also drag viewport dividers right on the screen to change a viewport's dimensions.

8 To quickly isolate one or more objects in viewports, select the objects and choose Tools > Isolate Selection (or *alt Q*).

9

Organizing objects

EVEN A TRUE ARTISTE needs to get organized once in a while. Object names, layers, and selection sets are all part of keeping your scene tidy so your work will be as fast as possible.

Keeping the scene organized is especially important when you need to pass it on to someone else. On the receiving end, there's nothing worse than getting a scene full of Box01 and Box02 with no layers or selection sets in sight.

Be kind to your fellow artists (and to yourself!) and take a few moments to get your scene in order. You'll be glad you did.

1 The Object Properties dialog is "command central" for your objects. Choose Edit > Object Properties, or right-click and choose Object Properties from the quad menu.

2 Naming your objects intelligently is the first step toward good scene management. The quickest way to do this is to type in the name on the Modify panel.

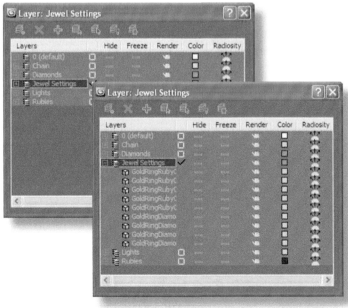

5 Organizing your objects into layers can also help keep things under control. In 3ds Max, layers refer to sets of objects, not physical layers. In other words, layer order has no effect on the appearance of a rendering. In the Layer dialog, you can also hide, freeze, and select objects. To open the Layer Manager, click the Layer Manager button on the toolbar or choose Tools > Manage Layers.

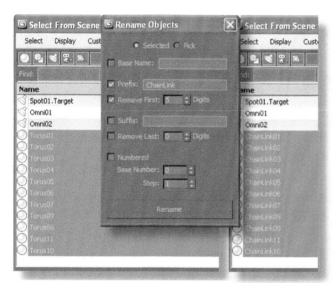

3 If you have numerous similar objects that need to be renamed, you can use Tools > Rename Objects to automate the process. Enter the number of digits (letters) to remove, and enter a new prefix to replace the letters removed. Here, a selection of toruses (Torus01, Torus02, etc.) is renamed while keeping the numbering intact.

4 You can temporarily hide objects to unclutter your viewports, or freeze them to make them impossible to select by accident. Right-click the screen and choose a Hide or Freeze tool from the quad menu.

6 A Selection Set is a name given to a selection of objects, providing quick selection of object sets from a dropdown menu on the toolbar.

7 Be sure to name your materials, too. If you have a lot of complex materials, consider naming your maps as well. You'll be glad you did.

8 Use Group > Group to group objects into one single selectable entity. While this is a common practice for architectural scenes, grouping makes animation difficult to control, so I don't recommend it.

Transforms and coordinates

T HE MOVE, ROTATE, AND SCALE buttons on the toolbar are called *transforms*. The Select and Move transform is your primary tool for lining up objects in a scene.

Coordinate systems work hand-in-hand with transforms. A coordinate system determines what 3ds Max considers to be the X, Y, and Z directions at any given moment. While you can choose a variety of coordinate systems from the dropdown menu on the toolbar, the ones you'll use most often are View, World, and Local.

1 The default coordinate system for orthographic viewports (straight-on views) is the View coordinate system. In the Top, Front, and Left views, X always points to the right and Y always points up in whichever viewport is active at the moment.

4 A different coordinate system can be assigned to each transform. When you want to change the coordinate system, be sure to choose the transform first. If you want a single coordinate system to apply to all transforms, choose Customize > Preferences, click the General tab, and turn on Constant in the Ref. Coord. System group.

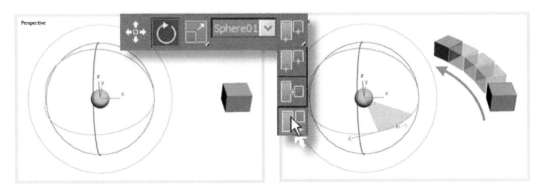

6 The Pick coordinate system uses a specific object's pivot point as the center for transforms on all objects in the scene. After you pick the object to use as the center, choose the Use Transform Coordinate Center button from the flyout. This type of coordinate system is most useful for rotating one object around another.

2 The default coordinate system for the Perspective view is called World. Here, Z always points in the up direction. The coordinate system is still listed as View on the toolbar because having the World system in the Perspective view is part of the View coordinate system's definition.

3 The Local coordinate system is aligned with the selected object's pivot point. Each object you create is automatically assigned its own XYZ pivot point. If the object has been rotated, the Local coordinate system allows you to easily move the object in the direction in which it's rotated.

5 The pivot center button next to the coordinate system dropdown menu determines whether the object will be transformed around itself (Use Pivot Point Center), the center of the selection (Use Selection Center), or some other object (Use Transform Coordinate Center).

7 To transform an object by a specific amount, you can enter a value on the status bar, or right-click the transform button to bring up a type-in entry dialog.

8 The Transform Toolbox (Edit menu > Transform Toolbox) gives you instant access to all the transform tools, plus some great options for controlling the way transforms work in viewports.

13

Organizing objects: a matter of choice

WITH A CHOICE OF SO MANY TOOLS in 3ds Max for organizing objects, you have many options for managing your scene. Layers, for example, are not necessarily better or worse than selection sets. It's a matter of what works best for your purposes.

A selection set is simply a selection of objects that you give a name to. It's the easiest one to use, and I still have a soft spot for it. Select, enter a name on the toolbar, done. In the early days of 3ds Max, before layers were introduced, this was the primary tool artists used to organize objects. It wasn't uncommon for me to send a scene back to an artist with a note to rename the objects (please!) and then put them into selection sets so I could work with the scene.

Grouping has been available for just as long. This type of tool is common in 2D graphics and layout programs such as Illustrator and InDesign. While it works very well in 2D for just about anything, grouping has specific, limited uses in 3D.

For objects that won't be animated, grouping is fine. Architectural artists, for example, find it useful to group together all the furniture so they can move it around easily. This works because the furniture isn't going to be animated to fly around the scene (or so one would presume). The camera might be animated, but that won't have any effect on grouped objects just sitting there.

If the object is going to be animated, grouping becomes something that we in the 3D industry call A Bad Idea. If you animate the group to make it fly around, the animation keys are on the group itself as an object. If you later ungroup the objects, you will lose the animation keys. And if you open the group and animate individual objects within the group, and then ungroup the object, you get what we in the industry call A Big Mess. So for static objects, group away. For animated objects, use Dummy objects to keep it all together (covered in the Animation chapter).

Layers are new to more recent versions of 3ds Max. Architectural designers love layers because they're a mainstay of AutoCAD, a technical design program used by most of the known universe, and many architectural artists got their start with AutoCAD. I've made do with selection sets for so long that I don't use layers or containers very often, but they do come in handy for large scenes. And once in a while a client sends a scene back to me

with a note to please put everything in layers because that's what the folks at the other end are using.

Containers were recently added to 3ds Max for the purpose of sharing specific parts of a model across multiple users, as with a game development team sharing parts of a game environment. You can save parts of your scene into their own scene files, then assemble them into one master scene using XRefs or Containers. Containers haven't caught on outside this general usage, though.

If you model something made up of several separate objects, such as a chair made up of numerous bits of metal and wood, you can use the Attach tool (available with Editable Poly and Editable Mesh objects) to put them all together into one object. Each object will retain its own material and become an Element sub-object, which makes it easy to select the piece and move it around or assign it a different material.

In short, no one method for scene organization does it all. Try them out and use what works best for a particular set of objects, a specific scene, or you personally.

Roger's top 10 reasons why you can't select your object

MY GOOD FRIEND Roger Cusson is, like me, a longtime instructor on 3ds Max. One day we got to talking about the challenges of teaching such a large and complex program, and we agreed that the biggest barrier new students have is confusion about selecting objects.

Roger jokingly proposed that since we go over these pitfalls in every class, he should publish a list of Roger's Top 10 Reasons Why You Can't Select Your Object. The list never actually got published until now. As a bonus, I've included a cutout reminder list that you can tape to your laptop or computer case for easy reference. So here is the list, printed for the first time in the first edition of this book and back by popular demand:

1 The current selection is locked, preventing you from making a new selection. You can tell if this is the problem by checking the Selection Lock Toggle on the status bar to see if the button is turned on. Click the button to turn it off, or press the space bar.

2 You are attempting to select an object in a wireframe view by clicking in its volume area rather than on the wireframe. Click the wireframe, or change to a shaded viewport and click the volume.

3 The object is frozen. Right-click anywhere in the viewport and choose Unfreeze All, or use the unfreeze options on the Display panel.

4 A creation button, such as Box or Sphere on the Create panel, is still clicked, and a selection tool (such as Select Object) is not currently selected. Right-click a couple of times to turn off the creation tool, or click a selection tool.

5 You are still at the sub-object level for one object. At a sub-object level, you can select only sub-objects of that object. Return to the base level of the object by turning off the sub-object level.

6 The Window/Crossing toggle on the toolbar is set to Window, and you are making a Crossing selection. Click the button to toggle to Crossing.

7 You are clicking the back side of a one-sided object such as a Plane. Rotate the view and click the other side.

8 You are currently using a tool that 's expecting a selection for that specific tool. For example, if you click Select and Link then click Select by Name, you will pick an object to link to rather than simply selecting an object. Click Select Object to turn off the other tool and enable selection.

9 The Selection Filter is limiting your selection. Set the Selection Filter to All.

10 You are trying to use *Shift* or *alt* instead of *ctrl* to add to the selection. Use *ctrl* to add to the selection, and *alt* to remove from the selection.

HOW TO CHEAT IN 3DS MAX
Roger's Top 10 Reasons Why You Can't Select Your Object

1 Unlock the selection (space bar, or turn off Selection Lock Toggle).

2 Click the wireframe, not the volume.

3 Unfreeze the object (right-click for quad menu, choose Unfreeze All).

4 Turn off the creation tool you're currently using, or click Select Object.

5 Get out of sub-object mode.

6 Make sure Window/Crossing is set to the mode you want.

7 One-sided object? Click the other side.

8 Turn off the tool that's expecting a selection, or click Select Object.

9 Reset the Selection Filter to All or Geometry.

10 Use *ctrl* to add to the selection, not *alt*.

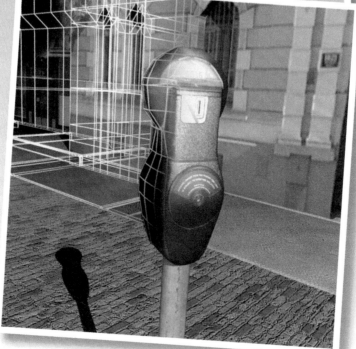

■ Modeling quickly
and intelligently
requires good
reference images
and a little
ingenuity.

1

Modeling

MODELS ARE the main building blocks of scenes. When creating a model, it's important to model just enough detail to make a good rendering. It's easy to get bogged down in small details that take a long time to model and won't even be noticeable in the final rendering.

Mapping, the process of putting textures on a model, is akin to modeling. In this chapter you'll learn simple mapping techniques that can reduce modeling time to minutes instead of hours.

10.1016/B978-0-240-81433-9.50002-7

Modeling tools

KNOWING the primary modeling tools in 3ds Max will make your work go much faster. Make sure you can find all these tools in the user interface, and take it from there.

1 Primitive objects are the starting point for most of your objects. Between Standard and Extended Primitives, there are more than 20 primitives to choose from. The box is the most commonly used base object for both simple and complex models.

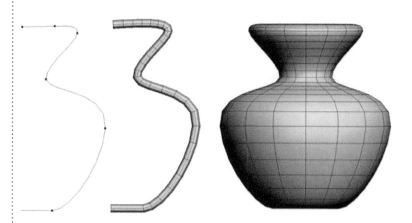

3 In some cases, a spline (curved or straight line) is the most straightforward way to create an object. The Sweep and Lathe modifiers, among others, will turn a spline into a 3D object.

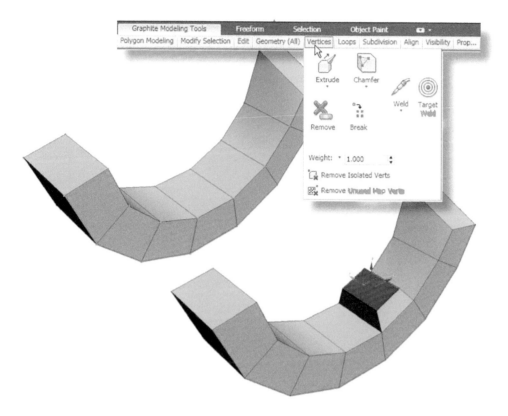

2 A primitive can be turned into an Editable Mesh or Editable Poly for direct access to vertices and polygons. You can access the tools at the Vertex or Polygon sub-object level by expanding the base object and choosing a sub-object level, or you can click directly on a tool from the Graphite Modeling Tools toolbar.

4 To clone an object, hold down *Shift* as you move the object. A Copy is independent of the original. An Instance maintains a connection between the two so any changes to one clone changes the other. References are a combination of the two, which is useful under specific circumstances.

21

Modeling

Reference images

T HE IMPORTANCE OF USING reference images for modeling cannot be overstated. An hour spent creating or cleaning up useful reference images can easily save you a dozen hours of modeling and tweaking.

The best tool for cleaning up reference images is Photoshop. By learning the Transform tools, you'll open up a whole new world of useful images that can even double as textures.

I've found the following tools most useful for image cleanup:

- Quick Selection
- Transform
- Distort
- Warp
- Guides

1 Take photographs or make drawings of the object you want to model. With a symmetrical object such as this fire alarm, a front and side view are sufficient. Take photos at as much of a straight-on view as you can get. You can also take a back and top picture if you like.

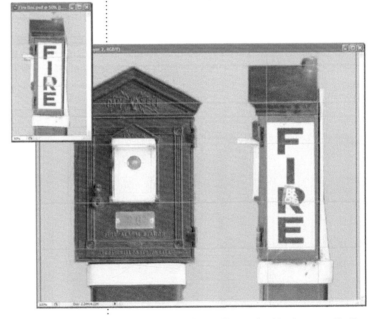

4 Use horizontal guides on the front view to line up the side view parts. You'll need to use the Distort and Warp tools liberally to remove the perspective from the side view. Utilize any obvious rectangular elements, such as the FIRE decal, to determine the correct vertical alignment.

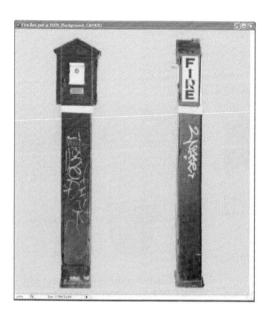

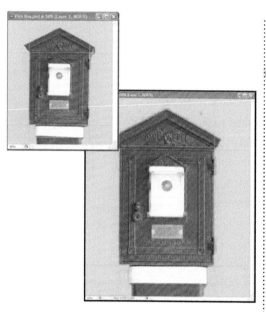

FireAlarm.tga
FireAlarm.max

2 Use guides to help you rotate the items straight.
Using a contrasting background color, erase the photo
background with the Quick Selection and Eraser tools. Resist
the temptation to waste a lot of time delicately erasing
pixels at the edges. The edges don't have to be perfectly
clean to use the images for reference in 3ds Max.

3 In this case, the base of the fire alarm in the front view
is straight, but the top is crooked. Straighten out the
image using the Rotate, Distort, and Warp tools as necessary.
Remove any perspective artifacts from the image. Here, I
erased the bit of the underside of the "roof" that was visible
at the upper right corner of the object.

HOT TIP

**Outdoor
photographs
taken on an
overcast day
have fewer
shadows and
more even
lighting than
those taken in
bright sunlight.**

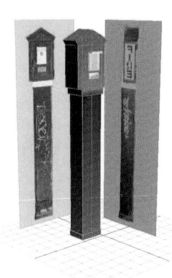

6 With a few modeled
details and the
reference image as a
texture map, you have an
instantly believable asset
for your scene.

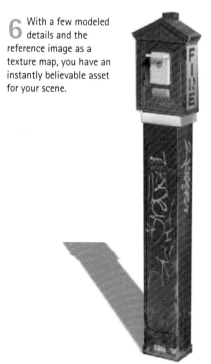

5 Save the image and use it as a guide for your model's
proportions in 3ds Max. The details on how to do this
are covered in this chapter.

Virtual studio

A VIRTUAL STUDIO is a scene setup that provides the three-dimensional reference required to model a specific object. It's one of the prime tools used by expert modelers to get the job done quickly.

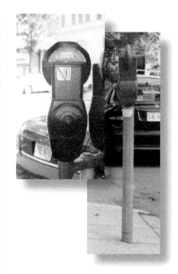

1 Get two views of the object you want to model. In Photoshop, paint out the backgrounds and remove any obvious perspective from the images as described in the Reference Images cheat.

2 Create a perfectly square image that contains both maps. This will save your being concerned with the image aspect ratio when you use it in 3ds Max.

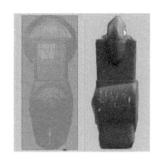

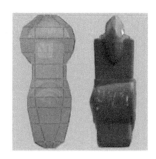

6 Make a box and position it in the Front viewport to align with the image. Press *alt X* to make the box see-through, and match its size roughly to the outer bounds of the front reference image.

7 Press *F4* to turn on the Edged Faces display, and increase the number of box segments to allow enough detail for the object. Convert the object to an Editable Poly by right-clicking the modifier stack and choosing Convert to Editable Poly.

8 Now you can directly access the box's vertices (points) and edges (lines between points) to shape the object. At the object's Vertex sub-object level, move and scale vertices to shape the object to fit the image. Be sure to select vertices using a bounding area so you get the ones in the back as well.

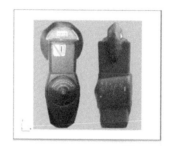

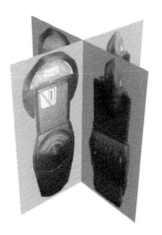

MeterRef.jpg
MeterMap.jpg
MeterPole.jpg
Meter.max

3 In 3ds Max, create a material with the reference image as a Diffuse map. Set the Self-Illumination value to 100 to make the image show clearly in viewports regardless of the lighting.

4 Create a plane in the Front viewport with square dimensions and one segment along each side. Apply the material to the plane, and turn on Show Map in Viewport. Press **F3** to toggle the viewport to a shaded view. Because the map is square, you don't have to be concerned about its aspect ratio.

5 Clone and rotate the plane by holding down *Shift* while rotating it by 90 degrees. The resulting arrangement, called a *virtual studio*, provides a framework for creating a 3D model.

HOT TIP

To speed up the modeling process, model one side of the object and use the Symmetry modifier to mirror it to the other side.

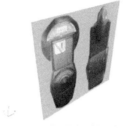

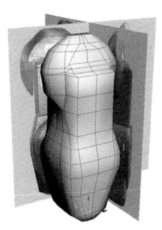

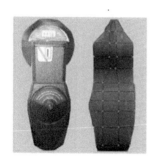

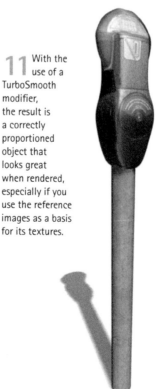

11 With the use of a TurboSmooth modifier, the result is a correctly proportioned object that looks great when rendered, especially if you use the reference images as a basis for its textures.

9 In the Left viewport, move vertices to match the side image.

10 With the help of the virtual studio, finish shaping the object as necessary. If necessary, add more edges with the Cut tool, or with the Connect tool as described in the 15-Minute Building cheat.

15-minute building

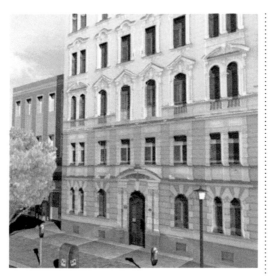

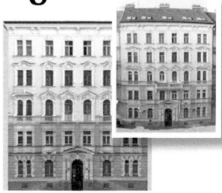

1 Get a photograph of a building with a nearly straight-on perspective. In Photoshop, correct the perspective distortion and clean it up. In this image, I've removed the flag, signage, and balcony from the facade. Note the background color, which is similar to the building color.

WHEN YOU NEED TO POPULATE a scene with buildings, you can do it with a long, arduous process. Or, if you like, you can do it the quick and easy way. Which would you prefer?

The Preserve UVs feature of the Editable Poly object makes it possible to visually shape the building right to the map without leaving the Front viewport.

4 Count the number of horizontal segments you'll need to extrude windows and other details. Here, I counted one for the top and bottom of each window with an extra segment for each arched window. There's one segment near the top that will be used to shape the roof, for a total of 16.

7 Access the Vertex sub-object level. In the Edit Geometry rollout, turn on Preserve UVs. This will keep the map in place while you move vertices. Move each row of vertices to line up with its corresponding horizontal.

8 Using the windows as a guide, count how many vertical segments will be needed. Select the horizontal edges and use Connect again to add the segments.

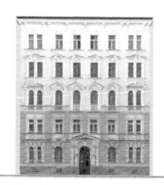

WhtBldgMap.jpg
WhtBldg.max

2 In 3ds Max, create a box and map the building image onto it. Assign a UVW Map modifier and use Align to View, Fit, and Bitmap Fit to map the image with the correct aspect ratio. The box won't have the right aspect ratio, but you need to get the image right before you can fix this.

3 Adjust the box size with parameters only, with the Show End Result On/Off Toggle turned on. If you use scaling rather than parameters, the map won't stay still while you change the box size. Collapse the modifier stack and convert the box to an Editable Poly.

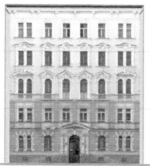

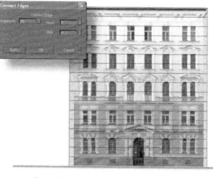

HOT TIP

To force vertices to move along existing edges, turn on the Edge option in the Constraints section of the Edit Geometry rollout.

5 Access the Edge sub-object level and select the vertical edges at the sides of the building. You'll need to make sure Window/Crossing is set to Crossing, and then draw a bounding area across the box horizontally.

6 Click Connect Settings and choose the appropriate number of segments. The horizontal segments appear on the box. If you can't see them, press F4 to turn on Edged Faces in the viewport.

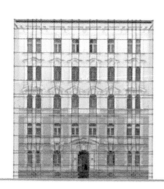

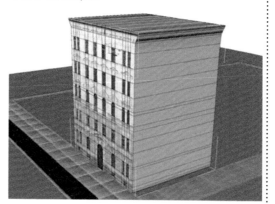

9 With Preserve UVs on, move the new columns of vertices to line up with windows. Note the adjustment of vertices around arched windows and the sides of the building.

10 If the texture wobbles as you move vertices, fix it by reapplying the UVW Map modifier. At the Polygon sub-object level, select the window polygons and extrude them inward. Voila! A 15-Minute Building.

27

Modeling around maps

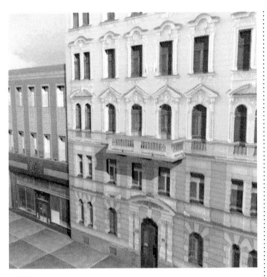

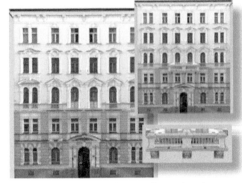

SHADOW-CASTING DETAILS make an important addition to your 15-minute building. A sign hanging off the facade, a balcony, flags, and other doodads multiply the 3D illusion.

The most convincing items use maps you've created from a photo. However, these items are often odd-shaped, and it can be tough to get the object and map to match. By using the Preserve UVs feature, you can use a map placed right on the object as a guide and get the modeling done right-quick.

For the 15-minute building in the previous cheat, the original image shows an ornate balcony. Adding the balcony to the scene as a 3D object adds depth to the rendering without a lot of work.

1 In Photoshop, cut out the balcony and paste it to its own layer. On the facade, carefully paint out the balcony by taking a guess as to what the building looks like in that area. This step was already done in the 15-Minute Building cheat.

4 Make a material with the balcony front map and put it on the box. Adjust the size of the box so the map looks right. That means you need to adjust the box until the map is correct, without any regard for whether the box is the right size.

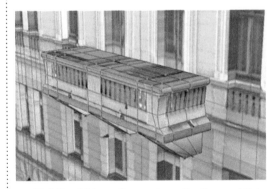

7 Modeling right over the mapping, rather than modeling and applying the mapping later, makes the process much simpler. Here, I've shortened the sides of the balcony to show only half of the map.

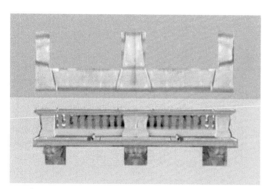

2 Separate the balcony picture into the front and top views, and save each one as a map. Not much of the balcony top is visible, so I've stretched the image to make its proportions match the balcony front.

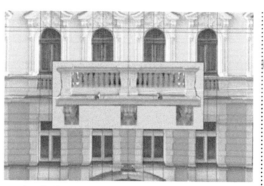

3 In 3ds Max, create a primitive object a bit larger than the final object. A box works best for the balcony, as it does for most modeling tasks. Create the box in the Top viewport.

WhtBldgMap.jpg
BalconyMap.jpg
Balcony.max

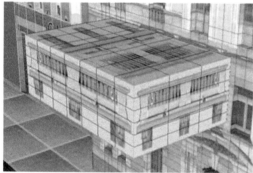

5 Make a judgement on the number of segments you'll need to model the object. Here we want sufficient segments for the supports and top detail. Collapse the box to an Editable Poly.

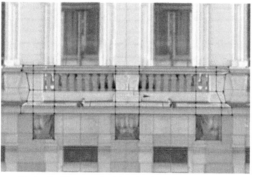

6 Go to the Vertex sub-object level, turn on Preserve UVs in the Edit Geometry rollout, and move vertices around to fit the map. You might need to delete polygons or use Extrude or Weld to make the right object shape.

HOT TIP

When creating maps from photos, fill in the background with a main color from the map. That way, if the map "bleeds" a little off the sides of the object in 3ds Max, the effect won't be so noticeable.

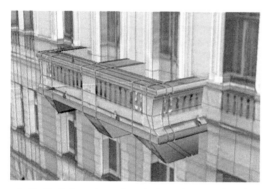

8 For the balcony top, select the top polygons and apply a UVW Map modifier to give that area its own Planar mapping, and collapse the stack. Apply a material with the balcony top map to the polygons, and extrude them down.

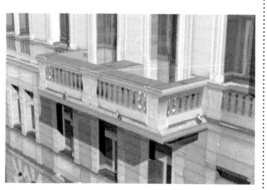

9 Add a shadow-casting light, and you have an interesting detail that gives a lot of depth with minimal effort.

29

Modeling from a plan

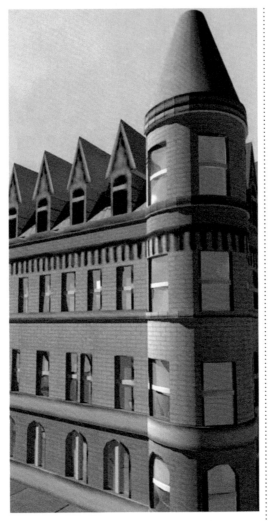

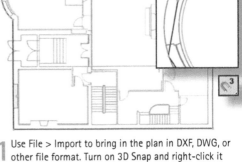

1 Use File > Import to bring in the plan in DXF, DWG, or other file format. Turn on 3D Snap and right-click it to turn on the Vertex option. Use Line to draw the outer wall by snapping to vertices on the plan. Set Steps on the Interpolation rollout to 0, and use Refine at the Vertex level to add any needed vertices on rounded areas.

4 Apply a Surface modifier to the spline. Set Steps to 0, and turn on Flip Normals if necessary to make the faces visible. Collapse to an Editable Poly, and at the Polygon level, select all faces and Extrude them to create the height.

A FLOOR PLAN can be helpful as a guide when creating a building or a design. But contrary to popular belief, it's not just a matter of importing the plan and extruding it. Most plans aren't built for easy extrusion; even if you try to weld the vertices together, you'll usually end up with a mess.

When you redraw the plan with your own lines, creating a building from a plan goes from a long nightmare to a quick, beautiful dream.

7 Instead of extruding the windows, you can create actual holes for them. Select the window polygons on both the inner and outer walls, and click Bridge. This tool deletes the polygons and creates new polygons to connect them.

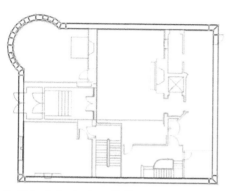

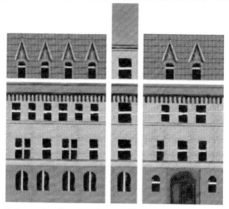

TurretBldg.dwg
TB*.jpg
TurretBldg.max

2 At the Spline level, use Outline to create another spline to define the inner wall, and add more vertices at the corners to line up horizontally and vertically. Apply a CrossSection modifier to connect the two splines together with segments. By creating the shape this way, you won't create interior polygons when you extrude.

3 Before extruding the plan, you'll need maps to guide the modeling process, one for each part of the building. Since this is a new building, I've drawn maps in Photoshop by pasting together brick textures and a few other items borrowed from photographs of similar buildings. The maps shown are for the side, turret, and front, respectively.

5 Place each map on the building (see the Multiple Maps cheat in the Materials and Mapping chapter). Then use Connect to make edge lines using the 15-Minute Building technique.

6 At the Vertex sub-object level, turn on Preserve UVs and move vertices to line up edges with windows and other elements. When working with corner areas like the turret, use all your viewports to help you select the correct vertices.

Interior walls can be created in the same way, by drawing lines over the plan and extruding them, and then using Connect to create horizontal and vertical edges. Knock out the doors by deleting polygons and using Bridge to close up the sides.

8 Create long, thin boxes to replace the window mullions. Create a separate plane almost as large as the building facade, place it behind the mullions to represent the window panes, and apply a reflective material to it.

9 Create the roof in the same way, using the maps as guides to horizontal and vertical lines. You can also extrude other detail on the outside of the building, such as the blocks below the windows.

Curvy curtain

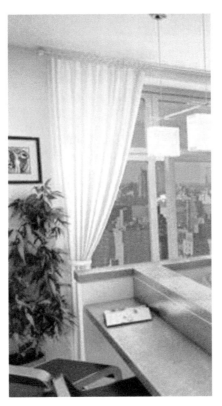

THE NURBS MODELING method uses curves to define a surface, as opposed to polygons. While NURBS caused a sensation when they were first included in 3ds Max back in the 1990s, nowadays they're mainly used for specialty modeling of softly curved surfaces. Here, NURBS make an easy, convincing curtain out of a handful of curves.

When making a surface with draping folds, it's important to draw each curve separately. While you could copy a single curve and scale each copy, the final model would have a stiff, computer-generated appearance. When you draw each curve separately, the inevitable differences between each one will result in subtle variations over the length of the curtain, making it look more realistic.

5 In the Front viewport, select the curve at the top of the curtain. On the Modify panel, in the General rollout, click Attach. Click each curve in descending order.

6 On the Modify panel, in the Create Surfaces rollout, click ULoft. Click the top curve, then click each curve in succession to create the curtain surface. Right-click to complete creation of the loft.

7 The ULoft might be inside-out. Choose the Surface sub-object, and click the Surface itself to select it. In the Surface Common rollout, toggle the Flip Normals checkbox to make sure the curtain is facing the right way.

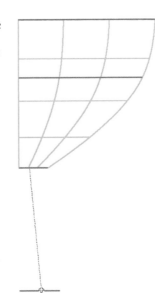

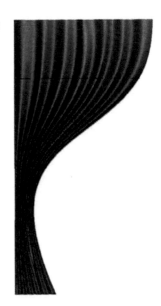

1 On the Create panel, choose Shapes, and pick NURBS Curve from the dropdown menu. Click Point Curve, and create a wavy curve in the Top viewport to set the shape for the top of the curtain. Right-click to end the curve.

CurtainStart.max
CurtainFinal.max

2 Create more NURBS Point Curves in the Top viewport to set the shapes at different vertical levels along the curtain's length. Make sure each curve has the same number of points and the same pattern of peaks and valleys. You can scale a curve after creating it, or edit points on the Modify panel at the Point sub-object level.

3 In the Front viewport, move each curve to correspond to its vertical position along the length of the curtain.

4 In the Top viewport, move the curves so they are on top of one another.

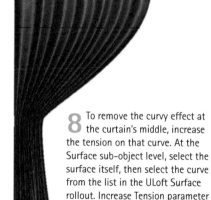

8 To remove the curvy effect at the curtain's middle, increase the tension on that curve. At the Surface sub-object level, select the surface itself, then select the curve from the list in the ULoft Surface rollout. Increase Tension parameter to 20 or 50. Do the same with the last curve to firm up the curtain at the bottom.

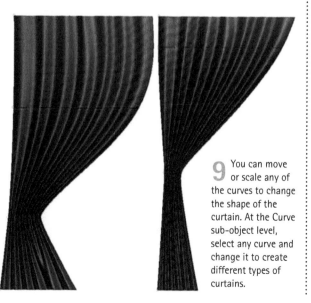

9 You can move or scale any of the curves to change the shape of the curtain. At the Curve sub-object level, select any curve and change it to create different types of curtains.

HOT TIP

NURBS stands for Non-Uniform Relational B-Splines. If you're curious about what this means, you can look it up on the Internet. But many artists enjoy long, profitable careers without ever understanding the exact technical details of the NURBS name.

33

BYO weapon

THE GAME STARTS in an hour, and you want to bring a custom weapon. What's a modeler to do?

This speed-modeling technique starts with a plane rather than a box, cutting in half the number of vertices you need to deal with in the first phase of modeling. The Shell modifier makes it 3D. After that, all you need is a bit of shaping and a texture, and you're good to go.

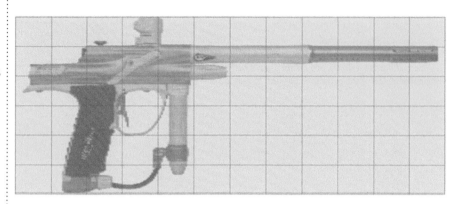

1 Create a plane the same size as the reference image, with sufficient detail to model the major shapes of the object. Use `alt` `X` to make the plane see-through so you can see the reference.

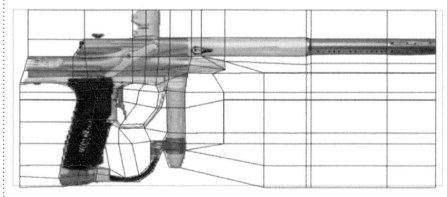

2 Convert the plane to an Editable Poly. Move the plane's vertices to fit the major parts of the object. As necessary, use Connect to create more edges, weld vertices together, and create new edges between vertices.

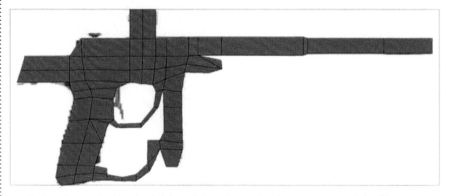

3 At the polygon sub-object level, delete all the polygons that do not form parts of the object.

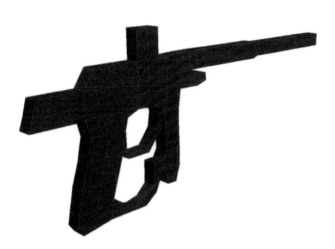

Gun.max
GunMap.jpg

4 Apply the Shell modifier to the object to give it some thickness. Collapse the object and convert it to an Editable Poly, and shape the object a bit more where needed.

HOT TIP

When an object has open areas such as the trigger area on the gun, starting with a box would require you to bridge edges after cutting holes. Using a Plane with the Shell modifier eliminates this modeling step.

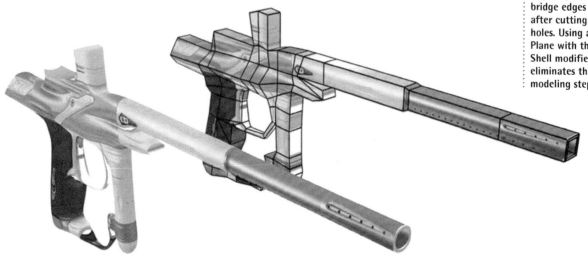

5 Pull out a few edges and scale down some of the polygons, and you have the basic weapon shape. Apply TurboSmooth, and set the Crease value at the Editable Poly's Edge sub-object level to 1.0 for edges that need to keep their shape. With the reference image as the texture map, you have a weapon that isn't perfect in every detail, but is good enough to get you in the game.

1 Modeling

Modeling a gorge

REALISTIC LANDSCAPE
elements require a certain
amount of detail. While it isn't
feasible to model every nook and
cranny, you need to give the object
some sort of shape to support the
texture.

With the use of contour lines, you
can create a custom surface that
fits your tileable map. Modeling
takes care of the major shapes, and
mapping takes care of the bumps
and crevices.

3 Apply the Surface modifier with Steps set to 0 to create the surface. Assign the rocky material to the new object, and use the UVW Map modifier's Acquire option to get the plane's mapping with the Acquire Absolute option. Collapse the new object's modifier stack to create an Editable Patch, and then collapse to an Editable Poly. Use Remove at the Edge sub-object level to remove unwanted edges that cross lines.

MountainTex.jpg
GorgeStart.max
GorgeFinish.max

1 A reference photo serves as both an inspiration and a texture source. In Photoshop, select the largest chunk of the image that you can get for the texture, and stretch it into a rectangle. Turn it into a tileable texture with the technique described in the Preparing Textures topic in the Materials and Mapping chapter.

2 Apply the texture to a plane in 3ds Max, and use Bitmap Fit to fit the mapping to the bitmap's aspect ratio. Use the Line tool to draw contours that follow the rocky ridges in the texture. Select the leftmost line, and use Attach to attach the lines in sequence going from left to right. Apply the CrossSection modifier to create connecting lines.

HOT TIP

Allowing the texture to repeat across the plane three or four times will give you a larger canvas for tracing the contours.

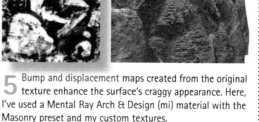

4 At the Polygon sub-object level, use Bevel to pull out rocks from the surface. Reapply the UVW Map modifier as needed to restore the mapping. Apply a TurboSmooth modifier to smooth out the rocks.

5 Bump and displacement maps created from the original texture enhance the surface's craggy appearance. Here, I've used a Mental Ray Arch & Design (mi) material with the Masonry preset and my custom textures.

Modeling
Custom engraving

W HEN MODELING, you'll occasionally run into a need to subtract one object from another. The ProBoolean tool was created for just these situations.

An engraving is a classic example of the need for subtraction. In life, engraving a piece of wood or metal is as simple as taking a drill to it. In 3D, the operation is much more complicated, requiring intricate calculations of polygon positions and intersections, and creating new faces to represent the subtracted area.

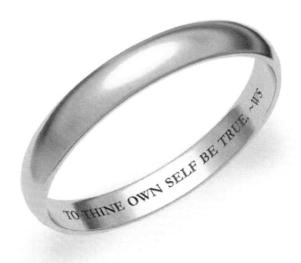

The ProBoolean tool is a tricky beast and prone to making a mess if you don't follow its rules. For this reason, the ProBoolean tool (and its older, less capable cousin, the Boolean tool) should be used only when no other means will serve. An engraving is just such a case.

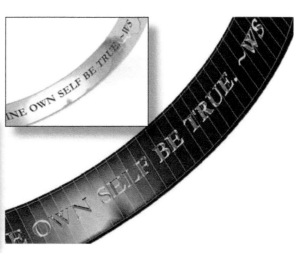

5 Collapse each object to an Editable Mesh. An object with a PathDeform modifier won't collapse completely, so you'll need to use Tools menu > Snapshot to create a mesh from it. Hide the original object.

6 Select the object to be engraved. On the Create panel, click Geometry, and choose Compound Objects from the dropdown. Click ProBoolean. Make sure Subtraction is selected as the operation. Click the Start Picking button, and pick the punch-out object. Wait a few moments while the ProBoolean tool computes the new mesh.

7 Inspect the punch-out area. Very likely, there will be slightly creased or pinched faces in areas that are supposed to be smooth. These creases will ruin the appearance of the rendering. Apply the Smooth modifier with Auto-Smooth to smooth them out. Experiment with different Threshold angles to see what works best. You can judge which values are working just by watching the object's appearance change in the viewport.

RingStart.max
RingFinal.max

1 Create the object you want to subtract from or engrave. Giving the object enough detail to look good up close gives the ProBoolean operation the faces it needs to work correctly.

2 Create an object to punch out faces. The punch-out object should have more thickness than you want the cutout to have. In this case, I'm using text with an Extrude modifier applied to it.

3 Fit the punch-out object to the object to be engraved. Position the punch-out so it intersects the object at the appropriate depth to cut out the faces. Here, I've created a Circle path and applied a PathDeform modifier to the text. The text follows the Circle to fit inside the ring.

4 Apply a material to each object. Give the punch-out object the same color you want for the engraved faces. If you need to work on the materials to get them right, now is the time. Rendering times will increase dramatically after you perform the ProBoolean operation.

HOT TIP

It's always a good idea to save your scene before collapsing objects and before performing a ProBoolean operation.

8 If the Smooth modifier doesn't smooth out the rough areas, try the options on the Advanced Options rollout. Choosing Remove Only Invisible or No Edge Removal can make a difference. Each of these options takes time to compute, so be patient while ProBoolean does its calculations.

9 If the mesh is still lumpy or creased, reload the original objects and increase the level of detail, and try ProBoolean again. When you get it right, you'll have a beautiful rendering that will make people ask, "How did you do that?"

Modeling

Importing models

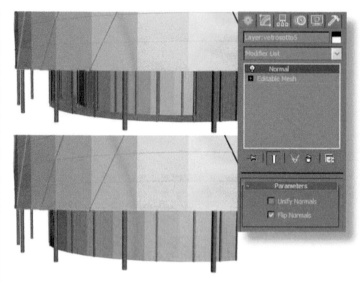

1 DXF files imported from CAD programs often have flipped or coplanar faces that won't render correctly. Try the Normals modifier's Unify option to make faces point the right way. If that doesn't work, you'll need to flip the faces manually with the Flip option. Sometimes these automated tools won't do the trick, and you'll find it's quicker to build the offending item from scratch.

WHILE SOFTWARE COMPANIES boast that their software can import and export multitudes of file formats, the file you get at the end of the pipeline is only as good as the tool that exported it.

A few file formats can be imported or exported from just about any program: 3DS, DXF, and FBX are the most common ones. But the generic nature of these files means that application-specific information, such as modifiers and lighting effects, isn't stored in the file.

Other common problems with imported objects are flipped faces and missing textures. Here are a few simple solutions to these problems.

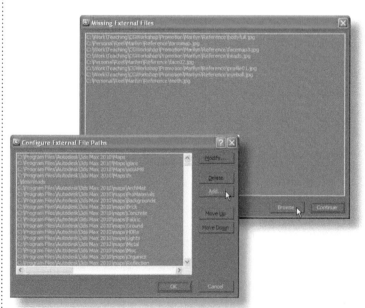

3 Although the 3DS file format can store texture information, it often loses the path to the textures. When prompted to find the maps (either upon loading or rendering the scene), click Browse to find the path, and add it to the Configure External File Paths list. If you add all the necessary paths you won't get any more error messages, and your textures will become available in the Material Editor.

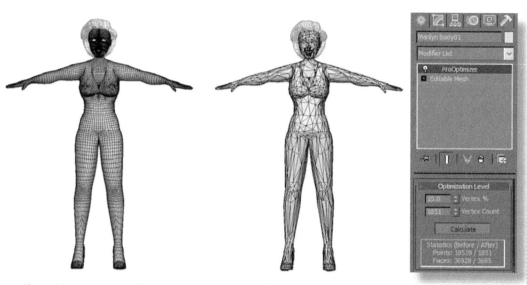

2 If a model exported to the 3DS format includes subdivision (for example, a 3ds Max model with a TurboSmooth modifier), the model collapses to an Editable Mesh on export, and you get the high-poly version when you import the file. Use the ProOptimizer modifier to bring the poly count down to a reasonable level. Click Calculate, and enter a lower percentage in the Vertex % field. The resulting mesh isn't as perfect as the original, but ProOptimizer is a vast improvement over earlier tools that attempted the same task.

HOT TIP

The 3DS file format is a generic format created by Autodesk in the 1990s. While it's adequate for transferring models between programs, it doesn't store animation. Use the FBX file format to transfer scenes that contain animation.

4 A common problem with exported files is incorrect scale. Features like Mental Ray and Reactor work correctly only if all objects are at real-world scale. And if the object is at an extremely small scale, you won't be able to render it due to the camera's Clipping Planes, which can't see objects that are less than 0.1 units from the camera. In general, rigged characters don't scale well, so scale the environment rather than any characters. Avoid scaling objects that have been animated with Bones or IK tools, as scaling will mess them up completely.

How to make a mess with modeling

WHEN YOU SET OUT to model an object, your primary concern is to give the model the right overall shape to represent the object. But right behind that concern is the necessity to create a clean model that will be easy to edit, and that will work in a variety of rendering and animation situations.

Consider a toy car model as an example. To create the body of the car, the most obvious approach is to draw a couple of splines to represent the shape, attach them together, and use the Extrude or Bevel modifier to create a 3D object.

While this is all fine and good for getting the basic shape of the car body, consider what happens afterward. The model is not quite smooth enough, so you apply the TurboSmooth modifier, and that's when you experience the disaster. The model collapses into itself and makes a mess. Even if you don't apply TurboSmooth, just try applying a Bend modifier to it to experience a completely different kind of mess.

What went wrong? When you use Extrude or Bevel on a spline, you're taking a gamble with the face structure. To see what I mean, select the object and turn off the Edges Only option on the Display panel. The edges on such an object go every which way, creating long, thin, triangular faces that the TurboSmooth modifier doesn't like.

A better approach is to start with a Plane, convert it to an Editable Poly, and shape the car's profile by deleting polygons and moving vertices around. Then apply a Shell modifier to give it some thickness, or use Extrude or Bevel at the Polygon level to shape the object. You might need to use the Flip option on some

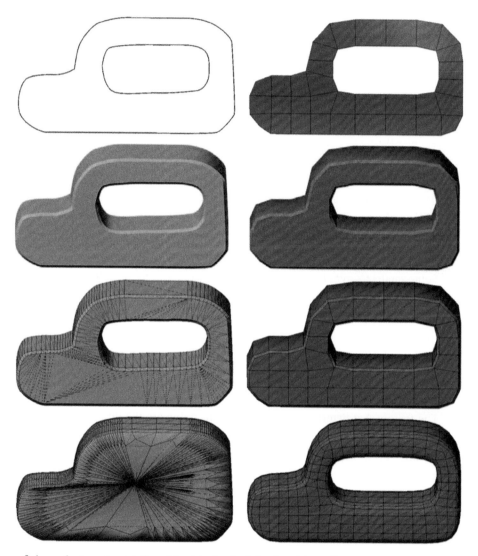

of the polygons to get the object to look right, but it's well worth the trouble. When you apply TurboSmooth to it, the result is beautiful to behold.

TurboSmooth works well with three-sided and four-sided polygons of a fairly regular shape and size, but not so well with any other kind. Modifiers like Bend and Taper work best with these types, too.

In general, you can use splines all you like with the Sweep and Lathe modifiers, and as Loft paths. Using the Extrude and Bevel modifiers with splines works fine with a boxy object that isn't going to be smoothed. But if you plan to use TurboSmooth with an object, use the Plane modeling method instead.

Secrets of the spline

SPLINES MIGHT SEEM LIKE a lesser cousin of polygons, but in practice they have many uses. Some types of modeling, such as vehicle and aircraft design, require these smooth curves to define the shape of the object.

Splines have a long history. Back in the shipbuilding days of yore, naval architects created their hull designs by bending a strip of wood over and around a series of weights, creating a smooth curve. The piece of wood was called a *spline*. In computer graphics, this idea was borrowed to create what is now called the spline.

Some modelers avoid splines, saying they take too long to adjust. But if you learn to draw them right the first time (or at least close to right), you'll have the freedom to use splines for the jobs that call for them.

I won't lie and say that drawing splines is intuitive. When I first started using splines, I cursed them more often than anyone. But then I figured out a few key things about them, and now I can draw them nearly perfectly the first time, every time.

The factors that determine the shape of the spline are the placement of the vertices and the curves going in and out of them. You can get a large curve out of just two well-placed vertices. The fewer you use, the easier it will be to adjust the curves.

Start by drawing as few vertices as possible and see what you can get out of that. When drawing a spline, a single click makes a corner vertex, where the spline will go straight in and out of the vertex. To get a little curve on it, drag the vertex while placing it.

The two key points to get into your head are:

You do *not* have to drag all the way to the next vertex before releasing the mouse button. Once the curve looks good for all the vertices drawn so far, release the mouse and move it to the next spot.

You don't even have to drag in the direction of the next vertex. Learn to ignore the line between the last vertex and the current cursor position, as this does not determine the shape of the line. After you drag to make the curve shape, you can release and move the cursor and place the next vertex anywhere you want.

Candles.jpg

HOT TIP

If you can't move the vertex handles after you've created the spline, press **X** to turn off the axis display, and press **F 5** to move handles left-right or **F 6** to move them up-down. When you've got the handles the way you want them, press **X** again to turn on the axis display.

After you've drawn your nearly perfect spline, you can move vertices around and adjust their handles (if they're the Bezier type). To change a vertex type, right-click the vertex and choose the new type from the quad menu. If you make a big mess of things, change all the vertex types to Smooth and take it from there.

It takes practice to get good at drawing splines, but really no more than an hour or two. That's all it takes to unravel the secrets of the spline. Just imagine how good you'll feel when you can create them quickly with no muss or fuss.

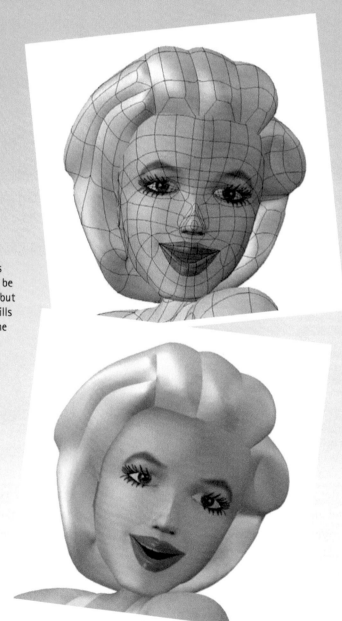

■ Low-poly characters that animate well can be a challenge to create, but the results, and the skills you'll develop along the way, are well worth it.

2 Character modeling

MODELING CHARACTERS is one of the most appealing uses for 3ds Max. We've all seen great animation and stills featuring characters seemingly sculpted from nothing into living, breathing people.

Your main tool for character modeling is persistence. Character modeling takes skills that you might not have coming into the field of computer graphics, but you can develop these skills with practice. A rule of thumb is that your first character will take a week to create and will look absolutely terrible; the second will take half the time and look twice as good; and successive attempts will continue to take exponentially less time and look even better. If you keep at it using the techniques described in this chapter, you'll eventually get where you want to be.

10.1016/B978-0-240-81433-9.50003-9

Character references

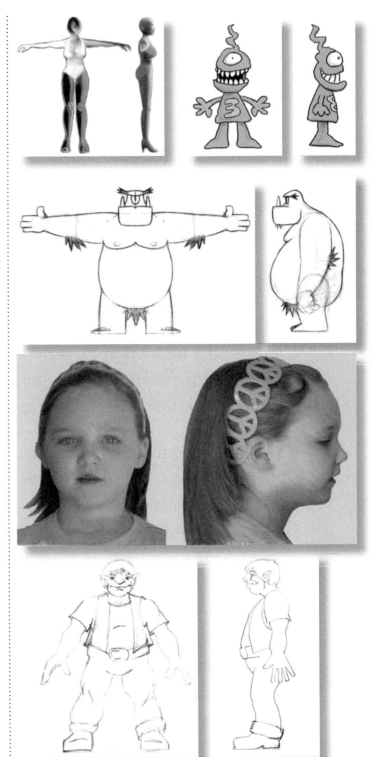

BEFORE YOU START modeling, you'll need good reference images to work with. At the very least, you'll need one image for the front of the model, and another for the side. The images don't have to be highly detailed, but they do need to provide enough information to create the basic shape of the model. If you don't have the skills to photograph or draw the images, get an artistic friend or colleague to help.

For highly detailed areas, such as the face or an intricate piece of jewelry or clothing, you can create a separate set of images and use them after you've completed the bulk of the model. Even with good reference images, after modeling the character you'll need to complete the finishing touches by visually checking the model itself against your vision of what it should be.

Starting with useful reference material is key to creating appealing characters. Time spent up front to make or get these images will pay off many times over in the time you'll save while modeling.

1 Reference images can be drawings or
photos, or combinations of the two.
Making the outlines of the character's body
clear is more important than color. The front
reference image should show the character
standing straight with its arms away from
its sides, and its legs slightly apart. Facial
reference should show a neutral facial
expression, or at least the same expression in
both pictures.

No3RefFront.jpg
No3RefSide.jpg
SethFront.jpg
SethSide.jpg
OgreFront.jpg
OgreSide.jpg
WomanRef.jpg

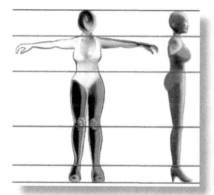 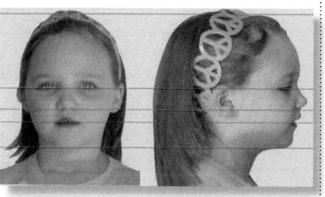

2 Using Photoshop, resize front and side images so the character is the same height in both images, and major areas of the
body or face line up. It can be helpful to put both reference images into the same image and use guides to line up the
images.

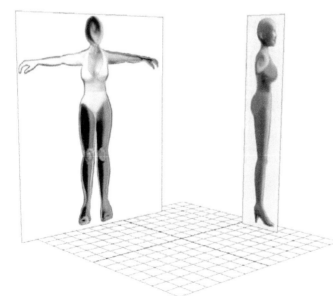

HOT TIP

For a body side
reference image,
it can be helpful
to erase the
arms to make
it easier to see
the shape of the
body from the
side.

3 Map the reference images onto two perpendicular planes in 3ds Max, leaving enough room to create the model where
the two images intersect. If the images appear too fuzzy in viewports, use Customize > Preferences > Viewports tab >
Configure Driver to choose a higher Download Texture Size, or turn on Match Bitmap Size as Closely as Possible.

Character modeling process

TO MODEL ANY CHARACTER, you'll use the same general process in 3ds Max. As with sculpting, you'll start with a simple object like a box or cylinder, and mold and shape the character using a variety of tools.

This is a basic overview of the process; the tools themselves are described in more detail in subsequent topics.

1 After you've set up your reference images, start with a box. Convert it to an Editable Poly so you can access the Polygon and Vertex tools.

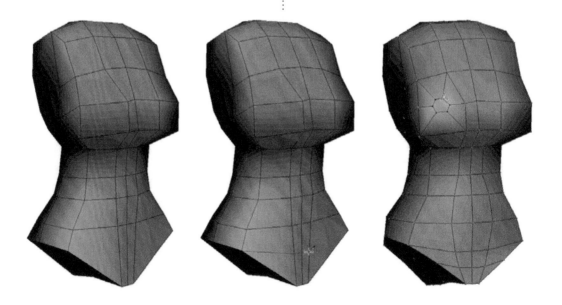

4 Add more detail and shape to the torso using Cut, Connect, Chamfer, and other cutting and refinishing tools described in the topic Chop Shop. You'll also need to clean up the edge flow with the tools in the Nip and Tuck topic.

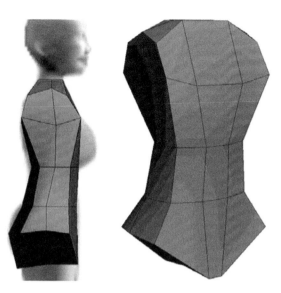

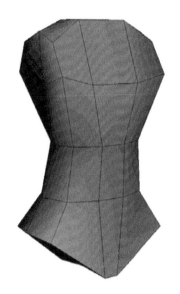

2 At the Vertex sub-object level, move vertices around to give the torso its general shape to match the front and side reference images.

3 Smooth out the shading to see the torso's shape more accurately. See the Polygon Building topic for details.

5 Form polygons on the body where the arms and legs will come out. Extrude the limbs, then form the hands and feet.

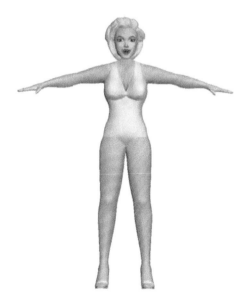

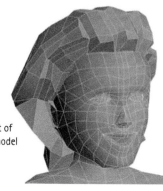

6 Using a separate set of reference images, model the head and hair.

7 Apply mapping and materials, then apply the TurboSmooth modifier as the final touch. See the Subdivision topic for more information.

51

Chop shop

1 To create more polygons, use the Cut tool at the Edge sub-object level to cut new edges.

CUTTING AND RESTRUCTURING your model's polygons is an inevitable part of character modeling. Although Editable Poly and Editable Mesh have numerous sub-object tools, you'll find that you use the same few over and over again. Here you'll find a guide to the most popular and useful tools.

Most of these tools can be found on the Graphite toolbar, where you can easily choose them rather than hunting for them on the command panel.

4 You can draw a new edge in a specific place with the Create tool at the Edge sub-object level.

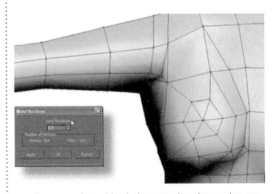

7 Every once in a while during your chopping session, you should use Weld to clean up coincident vertices. Extra vertices are a common cause of pinching.

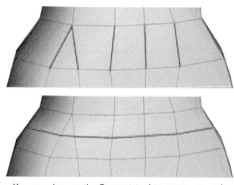

2 You can also use the Connect tool to create new edge loops around a specific area.

3 The Chamfer tool creates two edges from one. This tool often requires cleanup afterward with Target Weld.

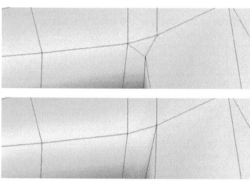

5 Target Weld at the Vertex sub-object level welds one vertex to another. This is helpful for cleaning up areas with too many small polygons, which can cause pinching.

6 The Collapse tool at the Vertex sub-object level, similar to Target Weld, automatically welds all selected vertices into one.

HOT TIP

When cutting a new edge between two existing vertices, use Create to draw the edge rather than Cut. Using Create will avoid duplicate vertices that need to be welded later on.

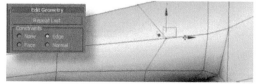

8 When you move vertices around, use the Edge constraint to keep them moving along the model's surface and not out in space.

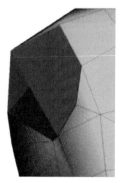
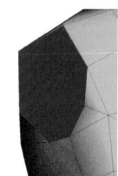

9 Before extruding limbs, use Make Planar at the Polygon sub-object level on the polygons you plan to extrude. This will give you a flat area to extrude cleanly.

Nip and tuck

WHEN STRIVING for a well-built model with three-sided and four-sided polygons, you will do a lot of plastic surgery on your model. Even if the shape of the model is right, you'll need to clean up edges to make them flow. A model with flowing edges doesn't pucker when you apply TurboSmooth, and will deform smoothly when animated.

Before checking for problem areas, be sure to smooth the model using the technique described in the Polygon Building topic.

1 Clean up any edges that end abruptly by cutting or creating new edges.

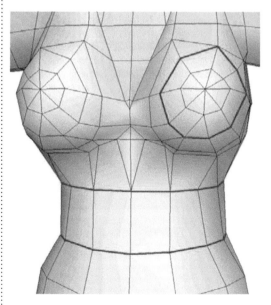

3 Whenever possible, form edge loops around major body areas. Use cutting and welding as much as necessary to make the loops flow.

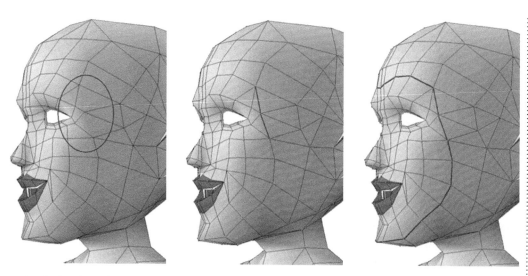

2 An *edge loop* is a series of consecutive edges forming a closed loop on the model. Edge loops make for smoother subdivision, and allow the model to deform more cleanly during animation.

4 If you've set up edge loops and the model still isn't smooth, you might need to turn hidden edges. When you click the Turn tool, hidden edges will appear, and you can see if the edges form loops as well. To turn an edge, simply click it.

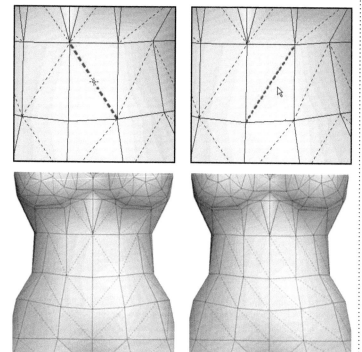

5 Use the Symmetry modifier to allow you to model just one side of the model and have it mirror to the other side. However, when you do this, all the edges are also mirrored, leading to hidden edges that don't flow. After you use the Symmetry modifier for the last time, collapse the stack and turn edges as necessary to get the flow back.

HOT TIP

If your model puckers at any given spot, you might need to weld vertices. Cutting edges sometimes creates new, extra vertices on top of existing ones, leading to puckering. Sometimes, the puckering is visible only when you render, or when you apply TurboSmooth.

55

Polygon building

SOMETIMES YOU MAKE such a mess of things that you have to delete polygons and make new ones from scratch. Although you won't need ths skill often, when you do need it, you'll really need it. If you know you can create polygons at will, you won't be afraid to cut and chop in your quest for the perfect construction.

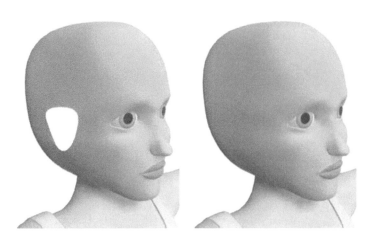

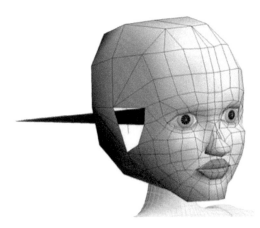

2 When drawing polygons from scratch, take care to click actual vertices on the model. Otherwise, the vertices will end up out in space.

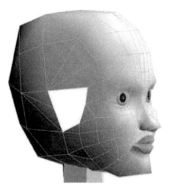

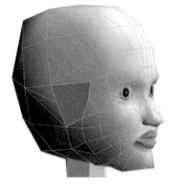

3 Instead of drawing polygons from scratch, you can select the open hole at the Border sub-object level of an Editable Poly, and use the Cap tool to close it up. You'll need to create new edges through the cap to make three-sided and four-sided polygons.

1 To delete polygons, simply select them at the Polygon sub-object level and press Delete. To draw a new polygon, click Create at the Polygon sub-object level, then click three or four vertices to outline the polygon, and click once more at the starting vertex to finish. Be sure to click vertices in sequential order and in a counter-clockwise direction. Going counter-clockwise will make the polygon's normals face the correct direction. If you use a clockwise direction, you'll have to flip the polygon's normals after creating it.

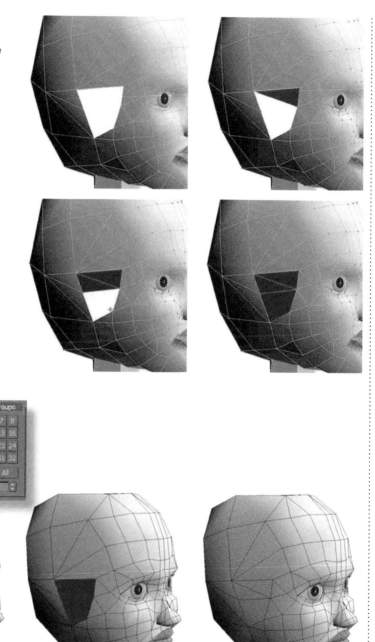

4 Newly created polygons won't appear smooth as they won't be in the same smoothing group as surrounding polygons. While looking at the Polygon Smoothing Groups rollout at the Polygon sub-object level, select one of the polygons near the new polygons and note which smoothing groups the polygon belongs to. Then select the new polygons, and assign them to that smoothing group.

Facial modeling

THE FIRST TIME you model a face, it might seem like an impossible task. Everyone instinctively knows what a face looks like. If you're not careful, the face will look creepy rather than appealing.

Good reference images and attention to detail are the essentials of modeling a decent face. That, and lots of practice.

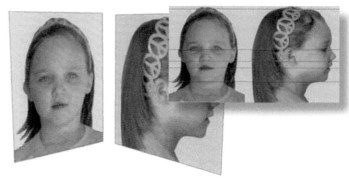

1 Use front and side photos or drawings as reference images for the head. Make Use Photoshop to make sure the images are lined up with regard to facial features. Arrange the images as a virtual studio, as described in the Modeling chapter.

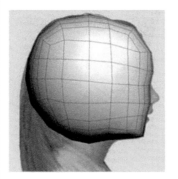
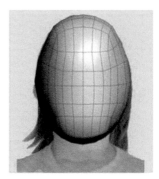

3 At the Vertex sub-object level, move vertices to shape the head object to match the reference images.

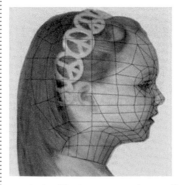
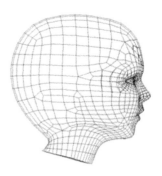

5 In the side view, move vertices to align with facial features, and extrude faces at the bottom of the head to create a neck. Assign the TurboSmooth modifier to see how the facial features are coming along. TurboSmooth tends to reduce the size of protrusions, so you might need to make the nose and chin larger once TurboSmooth is applied.

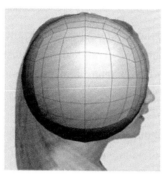
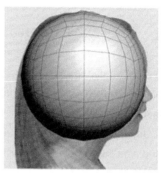

GirlHead.max

2 Create a Box about the same size as the head, with 3-5 segments along each dimension. Use the Spherify modifier to make the box spherical. Convert the object to an Editable Poly. At the Polygon sub-object level, select all the polygons and assign them to the same smoothing group to smooth out the box's edges.

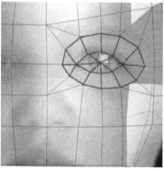
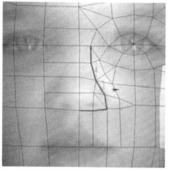
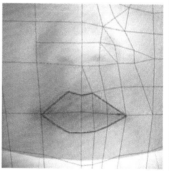

HOT TIP

Whenever possible, use a real face as a physical guide while you model. Feel the hills and valleys on your own face, or look at other people's faces to see how the contours flow.

4 Make the head object see-through so you can see the reference images through the head. Cut new edges around the eyes, nose, and mouth, and then clean up and add more edges as necessary.

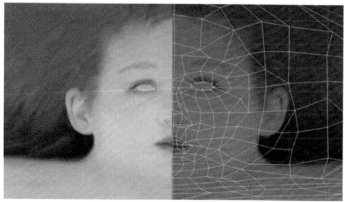

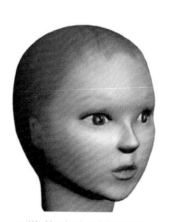

6 Using the front reference image as a base, create a map for the head. The map should look like the skin of a head laid out flat, as shown above. Apply the map to the head with Spherical mapping. Apply a UVW Unwrap modifier to the head, click Edit, and move the vertices around to make them match the image. You'll also need to apply a separate material for the eyeball faces.

7 Working back and forth between the map and the model, tweak the head until the face looks right. See the Hair topic for how to add hair to the model.

Hair

ONCE YOU'VE MODELED a nice head for your character, the next challenge is the hair. Hair creation technology has advanced a great deal in the past few years, mostly due to big-budget animated films featuring furry characters. But the technology that has trickled down to end users, such as the Hair and Fur modifier in 3ds Max, are memory hogs that can slow down your system beyond the point of usefulness.

Unless you're going for a 100% photorealistic look, a low-poly method will look good enough and won't slow down your system. In an architectural visualization where characters are viewed from a distance, cartoon hair is probably good enough. For animations, commercials, and games, low-poly mapped hair gives sufficient realism to get the job done.

When deciding what kind of hair to make, consider the final application. If modeling time is short, you might consider plopping a hat onto the character's head and calling it a day. But if you do need to make hair, consider these options.

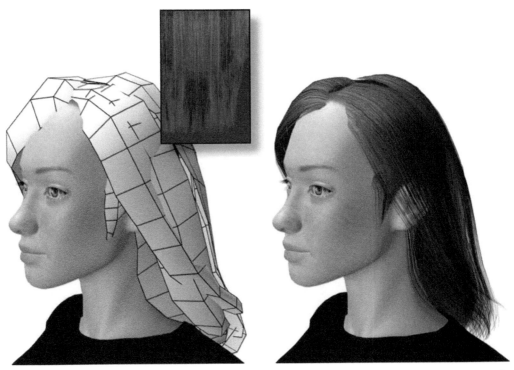

2 For more realistic low-poly hair, model strips of polygons and apply a texture map to them. You'll need to make several overlapping strips for a full head of hair. The advantage of hair like this is that you can animate it fairly easily, making it blow in the wind or respond to head movements.

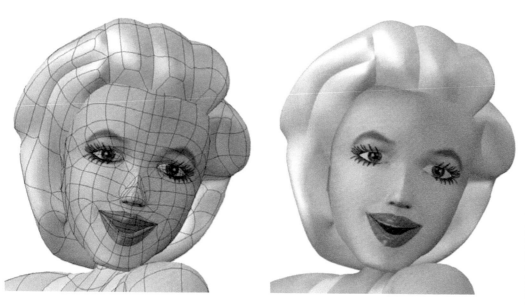

1 If you'd be satisfied with a cartoon look, you can model the hair as one solid object. With this type of hair, a plain color usually works better than texture maps.

HOT TIP

To help you achieve the look of a full head of hair, map the scalp itself with a hair-colored texture.

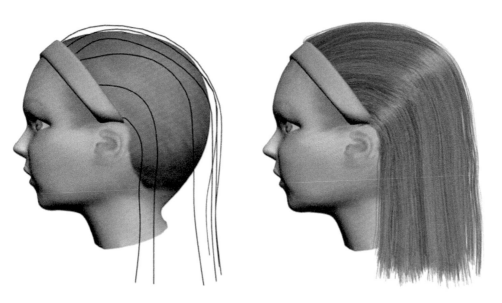

3 For the most realistic hair, you can use the Hair and Fur (WSM) modifier. With this method, you create several splines to create the shape of the hair, and the modifier fills in the strands in between. The upside is the realistic results you can get; the downside is the long render time.

Subdivision

THE TURBOSMOOTH AND MESHSMOOTH modifiers subdivide a model into more polygons, smoothing out the model in the process. MeshSmooth has more parameters, but TurboSmooth uses less memory and updates faster. For this reason, TurboSmooth has become the subdivision modifier of choice for 3ds Max modelers.

1 When modeling, try to keep all polygons three or four-sided. Such a model animates better, and also works well with the TurboSmooth modifier.

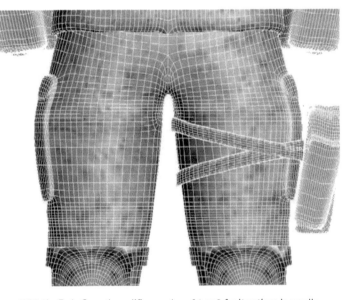

3 With the TurboSmooth modifier, a value of 1 or 2 for Iterations is usually plenty. To keep viewports updating quickly, you can set the Render Iters parameter to 1 or 2 and leave the Iterations parameter at 0, which will make the model render with the Render Iters value but not show it in viewports.

2 To make edges keep their shape when TurboSmooth is applied, increase the Crease parameter at the Edge sub-object level to 1.0.

4 If you want to apply a subdivision modifier like TurboSmooth to a skinned model, always apply it above the Skin modifier on the stack.

Poly modeling in practice

O N A TRIP to Cape Cod several years ago, I was introduced to the 2D artwork of Joey Mars. I was so captivated by No. 3, one of his signature characters, that I asked Joey if he wanted to collaborate on a 3D project. He provided 2D front and side views and a story line, and the result was a short television spot that still brings a smile whenever we see it.

Here, I walk you through the creation of this little guy using some of the concepts from previous topics.

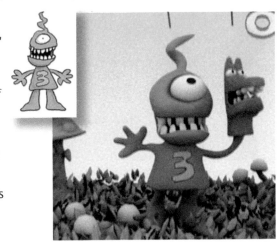

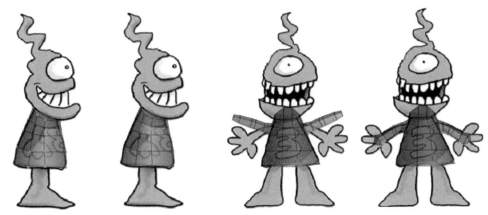

3 In the side view, move vertices around to line up polygons for the arm holes, one on each side of the body. You might need to use Connect at the Edge sub-object level to cut more edges. Select the armhole polygons, and Bevel or Extrude to get the basic arm shape. Then move vertices to shape the arms.

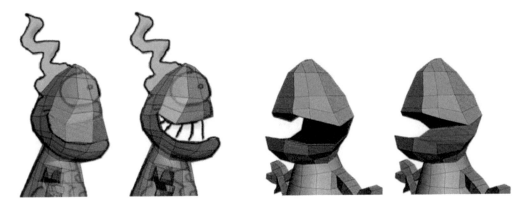

6 To create the mouth, move vertices to fit the mouth shape, and delete the polygons that are in the way. Then select edges on either side of the mouth and use Bridge to bridge across them with new polygons. Selecting the edges is easier if you turn off the See-Through option.

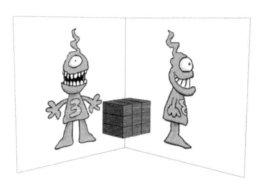

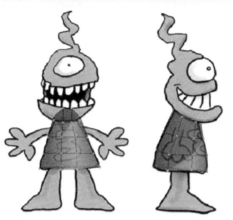

No3RefFront.jpg
No3RefSide.jpg
No3CatchFly.mov

1 Create or obtain front and side views of the character (called a *model sheet* in the 3D biz), and use it to create a virtual studio in 3ds Max. Create a box with 1-4 segments along the height, width, and depth.

2 Make the box see-through, and collapse it to an Editable Poly. At the Vertex sub-object level, shape the box to match the character's torso. Move vertices at the corners of the box to make it rounder.

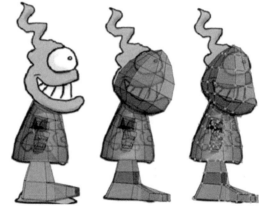

4 At the end of each arm, use Connect to cut extra edges for fingers. Bevel polygons with the By Polygon option turned on to create separate fingers.

5 In the same way you did the arms, extrude the legs and feet and shape them at the Vertex sub-object level. Then use Bevel to create the head, and shape it the same way.

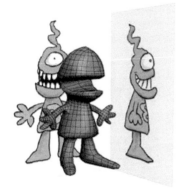

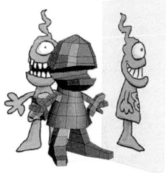

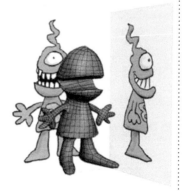

7 Apply the TurboSmooth modifier for some instant gratification. If TurboSmooth makes the model too squishy, select some of the edges and increase the Crease value to 0.5 or 1.0. This will hold the edges in place even when TurboSmooth is applied. Continue working with the model, using the same tools to extrude and shape any additional character elements.

Making animatable models

NOT ALL CHARACTER MODELS ARE created equal. A model that looks great in a still rendering is not necessarily going to animate well. This is why, when you're modeling a character, you need to pay attention to how you construct it in addition to how it looks when rendered.

Characters that animate well have these attributes in common:

The model consists of three-sided and four-sided polygons only. These types of polygons are necessary for smooth edge flow, but that's not all. Many game engines work only with three-sided or four-sided polys, and the TurboSmooth modifier itself behaves correctly only with these types of polygons.

Polygons are evenly sized and spaced. Long, thin triangles are bad news in a character model. Remember that when a character's arm or leg bends, the polygons themselves don't bend. You need enough evenly-spaced detail to make smooth bends at the character's joints.

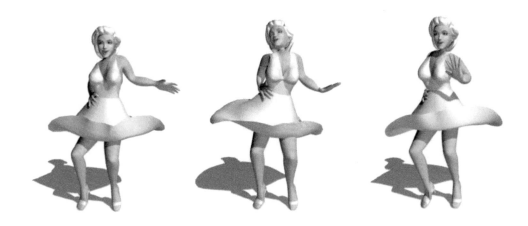

Edges follow natural bend and crease lines. When you sit, there's a natural V-shaped crease where your thighs meet your hips. When you bend your elbow, there's a natural crease where the wide part of your lower arm meets the upper arm. Make edges on your character to follow these natural creases.

Both visible and hidden edges flow smoothly. The Editable Poly is the form of choice for many character modelers because of its toolset, as compared with Editable Mesh. The catch is that a four-sided poly has a hidden edge that, if turned in the wrong direction, can wreck the smooth flow of faces. See the Nip and Tuck topic for a discussion of this problem and how to fix it.

Subdivision is used intelligently. If the model has three-sided and four-sided polygons and uses creasing where needed, you can create it with a low number of polygons, skin the model with ease with the Skin modifier, then put the TurboSmooth modifier above the Skin modifier on the stack. The result will be a model that animates easily and accurately, updates quickly on screen, and renders beautifully.

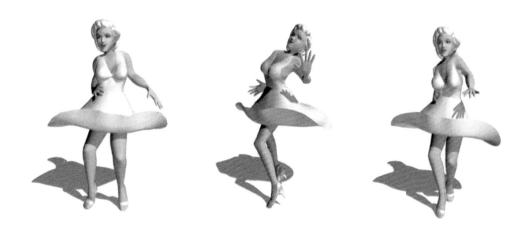

Practice without pixels

CHARACTER MODELING HAS ITS roots in the centuries-old art of sculpture. Becoming an expert at this ancient craft is a sure way to improve your modeling skills. But before you rush out and buy a set of chisels, consider these everyday alternatives. For a few dollars and a couple hours of play, you can increase your character modeling skills by leaps and bounds.

If you have children, then you might already have access to my favorite tool: Play-Doh. Get down with the kiddies and try your hand at sculpting a doll, a farm animal, or even a drooling ogre. You'll be amazed at how a few sessions with the gooey stuff will bump up your modeling skills, not to mention the benefit of giving you quality time with the little people in your life. Another favorite type of clay is Sculpey, available at many craft stores.

To get better at facial modeling, get a hold of some of those dummy heads that you see at wig shops, hat shops, and sunglasses stores. I got a rather large collection of plastic heads simply by going to a local wig shop and asking if they had any to spare. For $10 I picked up enough heads of all shapes and sizes to fill my mantelpiece. Visitors to my home look at me oddly (except other character modelers, who look at me enviously), but I have a goldmine of reference objects for facial modeling. I've found styrofoam heads particularly useful; you can draw on them with a marker to work out the polygon distribution.

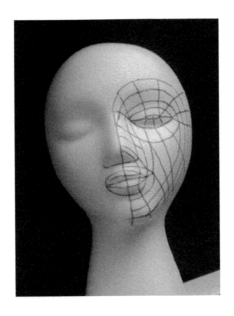

SQUID MODEL BY ELISE HATHEWAY

And then there are toys and action figures. Yard sales are chock full of plastic characters, animals, aliens, and monsters. For $5 you can get a bucketful of subjects for reference photos. Just take a picture of the figure from the front and side, clean up the photos a bit, and you have a couple of reference images. You can also take a few close-up photos to use as starter images for textures.

There's also good, old-fashioned tactile research. I once spent a few weeks taking care of my friend's dogs, a couple of adorable King Charles spaniels. These little fellows wanted to be petted all the time, and as I succumbed to their demands for affection I found myself fascinated by their furry little skulls. From this experience came the best dog model I've ever made. The dogs, by the way, could not get enough of my head-fondling, and they still jump for joy every time I visit them.

The possibilities for everyday research are endless. Want to learn more about how bodies are shaped? Give a loved one a massage. Spend an hour with your child comparing the shapes of your feet, or discussing the form and texture of a favorite toy. Cuddle up to your pet and discover how its legs fit into its hips.

Who says 3D modeling has to be a solitary activity?

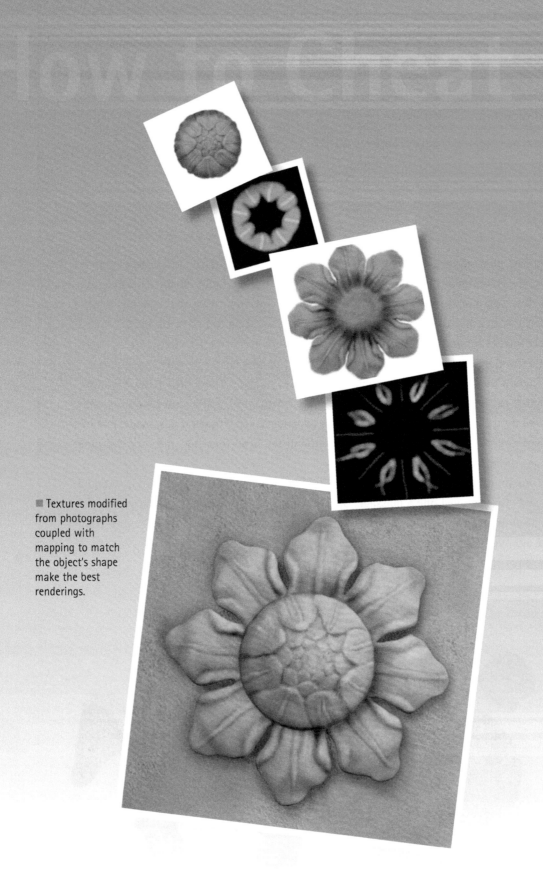

■ Textures modified from photographs coupled with mapping to match the object's shape make the best renderings.

3

Materials and mapping

HAVING GOOD TEXTURES is half the battle in making realistic materials. The other half is knowing how to create materials with the textures, and how to get them onto objects with the right orientation and size.

While a map is 2D and provides color information only, a material has a 3D aspect to it. Shininess, bumpiness, and transparency are all set within the material. You define a material with one or more maps, and then assign the material to a 3D object.

In this chapter, you'll learn how to create materials and apply mapping to suit your scene.

10.1016/B978-0-240-81433-9.50004-0

Materials and mapping

Material Editor basics

THE MATERIAL EDITOR is the heart of all materials and mapping. Here is where you specify the maps that will be applied to the object. This topic is a quick guide to the Material Editor tools you'll use the most often.

As of version 2011, 3ds Max has two different material editors: the compact Material Editor (the only version before 2011) and the Slate Material Editor. This topic covers the Slate version, which gives you a graphical representation of the material.

3 To assign the material to an object in the scene, first select the object, then right-click the Material header and choose Assign Material to Selection from the pop-up menu.

4 To assign a bitmap as the material color, scroll down the Material/Map browser display to find the Maps listing. Drag a bitmap node into the Active View, and choose a bitmap with the Select Bitmap Image File dialog.

6 To show the map on the object in viewports, select the Bitmap node and click the Show Standard Map in Viewport button on the toolbar. The color on the Bitmap node changes to a two-color display to indicate the map is being shown in shaded viewports.

7 To make the material shinier, scroll down the Parameter Editor to locate the Specular Highlights parameters. Adjust the Specular Level and Glossiness parameters to change the material's shininess. The shininess changes in both the viewport and renderings.

1 Open the Slate Material Editor by pressing the **M** key or clicking the Material Editor button on the toolbar. To start a new material, locate the Standard material in the Material/Map Browser under Materials > Standard. Drag the Standard material type to the right side of the Active View to create a Material node and start a new Standard material.

2 To change the material color, double-click the Material node header to make the material parameters appear in the Parameter Editor. Click the Diffuse color, and change the color in the Color Selector.

HOT TIP

To **switch between the Slate and Compact Material Editors,** use the Modes menu on either one.

5 Connect the new bitmap node to the Diffuse Color slot on the Material node. When you do so, a new parameter will appear, Controller Bezier Float. This value represents the Diffuse color amount. A value of 1.0 means the bitmap will be used for the full color. A value of 0.0 will use the plain Diffuse color, and values in between will mix the two.

8 To make the material bumpy, create a Noise map node and attach it to the Bump node of the material. Another Controller Bezier Float node appears. To make sure you know which one goes with which map, expand the Additional Params and Maps rollouts on the Material node.

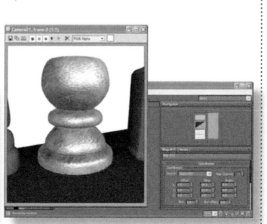

9 Double-click the Noise map node to see its parameters in the Parameter Editor. Click Show Standard Map in Viewport to see the Noise map on the object, and increase the Tiling parameters. You'll need to render the viewport to see the Diffuse and Bump maps working together.

Materials and mapping

Mapping coordinates

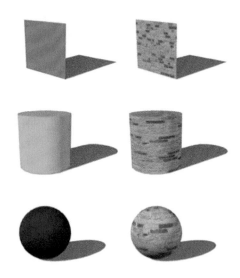

MAPPING IS A METHOD of specifying the orientation and size of maps on an object. For mapping, 3ds Max uses a special coordinate system that works with both flat and curved sections of objects. When you apply a material to an object, the object's own mapping coordinates determine the textures' orientation and size.

Every primitive, and just about every other kind of object you can create in 3ds Max, has mapping coordinates assigned to it by default. You can change the default coordinates by applying a UVW Map modifier to the object, where you'll have a selection of mapping types to choose from. In practice, you'll use just two or three of them for the majority of your work.

1 Every primitive in 3ds Max, and most other objects, have default mapping coordinates applied. As you'd imagine, the default mapping coordinates correspond to the general shape of the primitive.

4 Box, Spherical, and Shrink-Wrap have specialty uses for certain types of objects. You will rarely use the other types available with the UVW Map modifier.

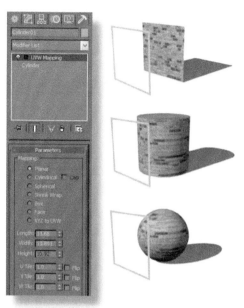

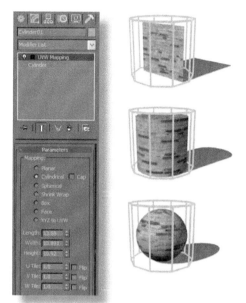

2 To change the mapping coordinates, apply a UVW Map modifier. The default setting for this modifier, Planar, projects the map onto the surface. This is the mapping type you'll use most often.

3 Cylindrical mapping looks good on curved surfaces, but warps at the edges of flat surfaces. This is the mapping type you'll use occasionally, mostly for round surfaces.

HOT TIP

3ds Max uses UVW as the letters for its coordinate system to avoid confusion with the XYZ coordinate system used to designate 3D space.

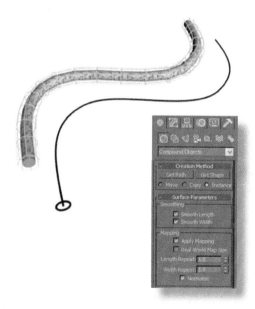

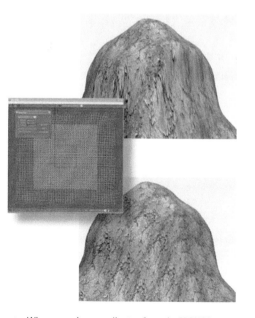

5 On a lofted object, you can use the Apply Mapping option to apply custom mapping coordinates that follow the loft path. For objects that follow a spline but aren't created with lofting, you can use the Unwrap UVW modifier's Spline Mapping feature.

6 When mapping coordinates from the UVW Map modifier don't give you exactly what you need, you can use the Unwrap UVW modifier to fine-tune the mapping. See the Unwrapping the Mapping topic for details on this feature.

Preparing textures

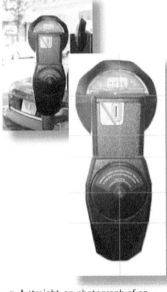
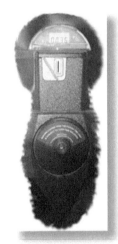

GOOD TEXTURE MAPS are the key to believability in your renderings. Realistic textures can bring a crude model to life, but it doesn't work the other way around. If your textures aren't up to par, your rendering will suffer accordingly.

Rather than paint your own textures, start with photographs as a base and do a bit of cleanup in Photoshop.

1 A straight-on photograph of an object makes an excellent basis for a texture map. In Photoshop, remove perspective with the Warp and Distort tools and clean up the image.

2 If the map doesn't match the object exactly, the background color will "bleed" onto the object. Use Photoshop's Smudge tool to push the edges of the image and make it larger.

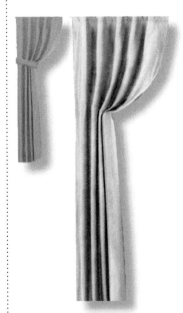

5 If you need a Bump map, make a grayscale version of your texture map and increase the contrast so you have a range from black to white.

6 Tiny shadows in crevices can be hard to produce with lighting and shadows alone. Build these shadows into the texture itself for a more realistic rendering.

3 You can also create textures right in 3ds Max by rendering an orthographic viewport. This is a great way to make animated textures for television and monitor screens.

4 To make a map tileable, cut it into four equal quadrants and swap each one with its diagonal counterpart. Clean up the visible edges in the middle, and the result is a tileable map. This technique is particularly good for landscape elements that need to be tiled over a large area, like grass, rocks, and sand. Use a texture like this with the Gradual Mix cheat to make a natural-looking landscape.

HOT TIP

To create textures from photographs, you can use the same techniques as those used on reference images in the Modeling chapter.

7 To create interesting shadows without having to model the objects, create a Projector map from a photo. See the Shadows chapter to find out how to use this type of map.

8 For quick people, cars, and trees, start with a photo and paint out the background to a transparent layer. Put the texture on a plane facing the camera. Create an Opacity map with solid areas as white and transparent areas as black, or use an alpha channel to hide the background. This technique is described in detail in the People, Trees, and Cars topic.

77

Applying a decal

APPLYING A MAP in a single spot on the model is a common need in 3D presentation. Instead of applying multiple materials, you can create a decal by using a PSD texture map with a transparent background.

1 Prepare the decal bitmap in Photoshop with a transparent background, and save it as a PSD file. This automatically stores the transparency information as an alpha channel that you can use in 3ds Max.

4 Assign the material to the object, and turn on Show Standard Map in Viewport. The decal appears all over the object. In the Coordinates rollout, turn off the Tile option for both U and V to remove the decal from all parts of the object except the area designated by the UVW Map gizmo.

BottleStart.max
BottleFinish.max
Label.psd

2 Apply a UVW Map modifier to the object, and leave the Mapping as Planar. Highlight the Gizmo listing at the UVW Mapping modifier sub-object level, and move and scale the gizmo so it roughly matches the desired decal size.

3 In the Material Editor, assign the PSD file as a Diffuse bitmap. Choose the Individual Layer option and pick the single layer available. Using this option, rather than Collapsed Layers, preserves the alpha channel.

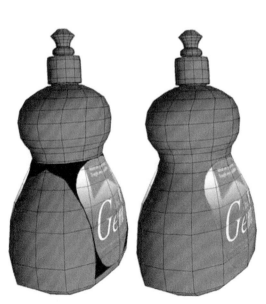

5 In the Bitmap Parameters rollout, make sure Alpha Source is set to Image Alpha. This utilizes the alpha channel and makes the corners of the decal transparent. If your decal corners are black, choose the bitmap again. Take care to choose Individual Layer and highlight the single layer.

6 Select the material itself to return to its base level. In the Blinn Basic Parameters rollout, change the Diffuse color swatch to the color of the rest of the object. Here, I've changed it to light green. Adjust the Specular Level and other parameters as you like.

People, trees, and cars

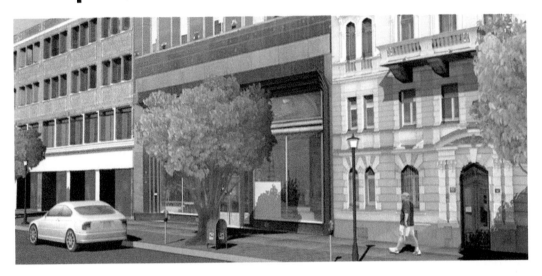

EXTRA SCENE ELEMENTS like people, trees, and cars are time-consuming to create as models.

You can save a lot of time by creating these extra elements as textures and mapping each one onto a plane. For a more three-dimensional look, you can also model a simple low-polygon object, and let the textures do most of the work.

3 In 3ds Max, create a material with the PSD file as the Diffuse map. In the PSD Input Options dialog, choose the Individual Layer option and select the single layer. This ensures that the background area will be transparent. In the Bitmap Parameters rollout, make sure Alpha Source is set to None.

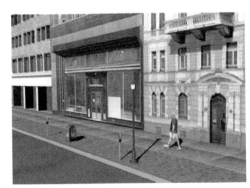

6 Place a shadow-casting light in the scene with Ray Traced Shadows. This will render shadows cast by transparent objects correctly, while a Shadow Map won't.

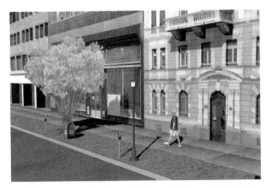

7 The same can be done with trees. The base of the tree will give away the fact that it's on a plane unless you hide it behind something, such as a mailbox.

PeopleTrees.max

1 Get together a few pictures of elements you want to use in the scene. Action poses work best for people, such as walking or sitting, rather than just standing there. For cars, get side and top photos, and back or front views as needed.

2 In Photoshop, paste the image onto a transparent layer, and erase the background. The Quick Selection tool can help with large areas, but you'll need to do some custom cleanup around the edges. Save each image as a PSD file.

4 In the Compact Material Editor, pick the material from the scene. Expand the Maps rollout, and drag the map from the Diffuse slot to Opacity slot as a Copy. Click the map in the Opacity slot, and set Mono Channel Output to Alpha. This will enable the renderer to generate shadows for the object. Change the Sample Type to a cube and turn on the Background option to check that the map background is transparent.

5 Create a plane in the scene and assign the material to it. Turn on Show Standard Map in Viewport to see the image in the scene. Assign a UVW Map modifier to the plane, and use View Align, Fit, and Bitmap Fit to ensure the mapping matches the PSD file's aspect ratio.

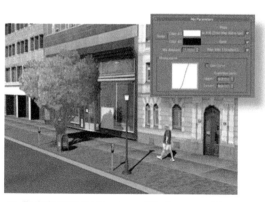

8 To darken the shadowy area of the tree, use a Mix map and mix the tree with black, with a black-to-white Gradient map to determine the Mix Amount.

9 A car can also be mapped onto a plane or created as a low-polygon object. Although it won't hold up to close scrutiny, it's fine as an auxiliary element.

Multiple maps

1 In the Compact Material Editor, select a material slot, click the Diffuse color for a new material, and change the color to the general color of the object. Assign the material to the object. Drag the material to another slot to make a copy, and give it a different name. In this second material, assign the texture map you want to use on just one part of the object.

YOU WILL OFTEN NEED to map several different textures onto one object. There are many ways to do this, but the one shown here is the quickest.

The key is to assign each material to an appropriate selection of polygons. The result is an automatic Multi/Sub-Object material with exactly the right materials in the right places.

This technique uses the Compact Material Editor, where it's easier to copy materials than in the Slate Material Editor.

4 Choose the Bitmap Fit option on the UVW Mapping modifier, and pick the texture map. This will resize the gizmo to the same aspect ratio as the bitmap.

7 Access the main level of the UVW Mapping modifier, and right-click it. Choose Collapse All to collapse the modifier stack. This embeds the mapping in the selected polygons.

MailStart.max
MailFinish.max
USPS_Logo.psd
USMail.jpg

2 At the Polygon sub-object level, select the polygons to which you want to apply the texture map. Assign the material to the object while still at the Polygon sub-object level. This assigns the material to the selected polygons only.

3 With the polygons still selected, apply a UVW Map modifier to the object. Use the View Align and Fit options to line up the gizmo with the approximate size and orientation.

HOT TIP

To see the bitmap on the object after assigning the material, turn on the Show Standard Map in Viewport option on the Material Editor toolbar.

5 If the texture needs to be moved or scaled, access the Gizmo sub-object level of the UVW Mapping modifier, and move or scale the gizmo.

6 If the map is a decal (meaning it's not meant to be tiled), turn off the Tile checkbox for both U and V in the bitmap's Coordinates rollout in the Material Editor.

8 Select another set of polygons and repeat the process: Assign a material, apply a UVW Map modifier, adjust the gizmo, collapse the stack. Repeat this as many times as needed to map the entire object.

9 After assigning multiple materials, click an empty sample slot in the Material Editor and use the eyedropper to pick the material from the object. The material is a Multi/Sub-Object material with all sub-materials assigned appropriately.

Background maps

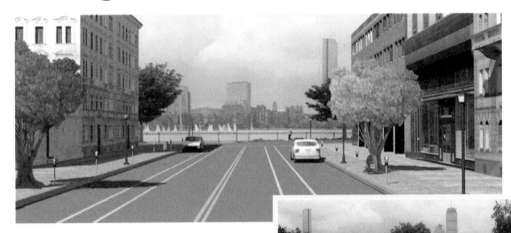

YOUR RENDERINGS can get a lot of mileage out of a photograph used as a background. The bitmap can be shifted or tiled within 3ds Max to match your camera's perspective.

3 Open the Material Editor. Drag from the Environment Map button in the Environment and Effects dialog to an empty material slot. When asked to choose the copy method, choose Instance. This will enable you to change the background map from within the Material Editor.

4 Select the background image slot in the Material Editor. Experiment with the Offset and Tiling values to eliminate stretching, or to make the parts you want to see show up in the viewport and rendering. You can also change the Mapping to Cylindrical or Spherical Environment, or use the Mirror option to get more sky at the top and trees at the sides.

1 To set up the background for the rendering, choose Rendering > Environment, click the blank Environment Map button, and choose a Bitmap. You won't see the bitmap in viewports; you need to render to see the background.

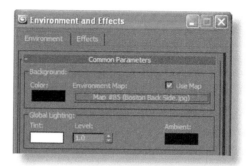

Background.jpg

2 To display the background in a viewport, activate a camera or Perspective viewport and choose Views > Viewport Background > Viewport Background (hotkey *alt* *B*). Turn on the Use Environment Background and Display Background options and click OK. If the image's aspect ratio differs from the viewport's, the image will appear squashed.

HOT TIP

When choosing a background map, look for images with landscape elements far from the camera.

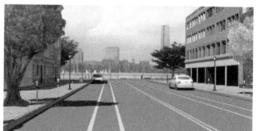

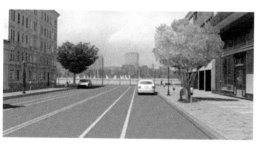

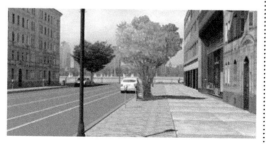

5 In the Coordinates rollout, the mapping type is set to Environ by default. This means the background will stay still even if the camera moves. If the camera is animated, you'll need to put the background texture on an actual 3D object in the scene. Create a giant sphere or cylinder around the scene, and apply a material to it that uses the background image as a Diffuse map. Turn on the 2-Sided option and set Self-Illumination to 100. With this type of setup, the background will pan appropriately when the camera moves.

Procedurally speaking

PROCEDURAL maps use algorithms (a series of equations) to generate an individual color pattern. You change the pattern not by painting pixels, but by adjusting parameters.

Although 3ds Max comes with many procedural maps, I use the Noise map and Gradient Ramp map more than all the others combined. With the examples here, it's easy to see why.

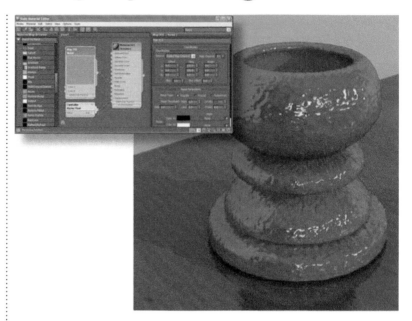

1 The Noise map makes a random pattern of black and white blobs. This type of map makes a great Bump map to give an object a bit of texture. Change the Source to Explicit Map Channel, increase the Tile values, and turn on Show Standard Map in Viewport to see how the map lies on the object. A Bump map only shows up on a somewhat shiny material, so be sure to crank up the Glossiness and Specular Level to see the bumps in the rendering.

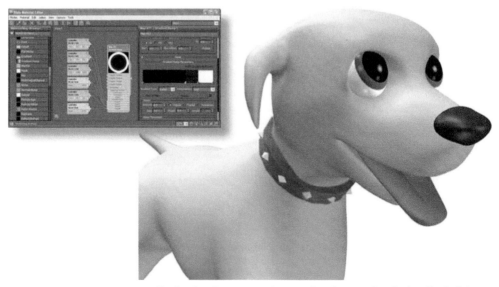

3 The Gradient Ramp map makes a gradient from a series of colors. The Radial type creates concentric circles, and the Solid Interpolation setting makes great cartoon-style eyeballs.

CandyBowl.max
DogEyes.max
PlanetGrad.max

2 The Noise map, like many maps, can be nested. In other words, the black or white channels in a Noise map can lead to another Noise map, or any map for that matter. Here, a Noise map is used as a background. The Size parameter is turned down low and the Noise Threshold: Low value is increased to reduce the amount of white. This produces a field of white stars on a black background. Then the black channel holds another Noise map made up of larger blobs of dark blue and purple, creating a rich background for a space scene.

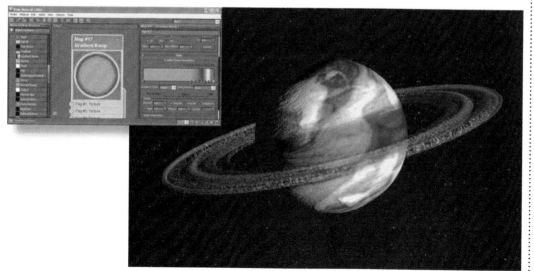

HOT TIP

If a Noise pattern is still too large with a small Size setting, increase the Tiling values in the map's Coordinates rollout. Procedural maps don't always appear accurately in viewports, so be sure to render the scene to see what the map really looks like.

4 You can also use a Gradient Ramp to generate rings of varying colors. Here, the Gradient Ramp map in the Diffuse channel is coupled with a Noise map in the Opacity channel to create the semi-transparent rings around a planet.

Gradual mix

A LARGE LANDSCAPE might call for gradual changes from one kind of ground cover to another. Examples are grass and dirt on a forest floor and rocks and snow on a mountaintop.

There are a number of ways you could create the texture map for such a landscape, such as mixing two maps using a Noise map to vary it across the surface. But with that type of setup, it's hard to control where each map appears on the terrain.

Instead, you can use vertex painting to put different maps on specific areas. This technique gives you fine control over the final look of the landscape while retaining natural-looking variations from one map to another.

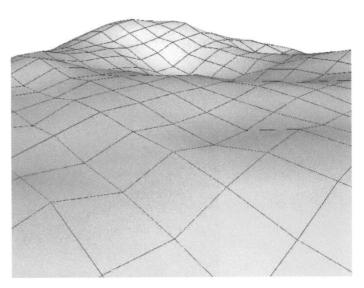

1 Create a terrain object with any method and apply a VertexPaint modifier to it. In the VertexPaint dialog, turn on Vertex Color Display - Unshaded. By default, all vertex colors are white. You'll use the VertexPaint tool to paint some of the vertices black.

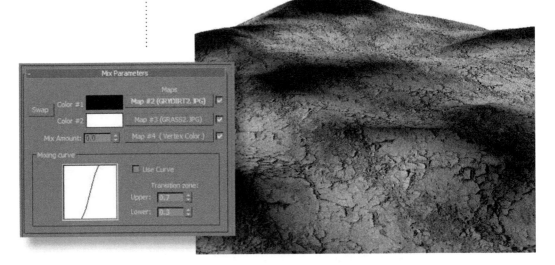

3 In the Material Editor, create a Standard material with a Mix map in the Diffuse map slot, and assign it to the terrain. Select a Color 1 map for the black areas and a Color 2 map for the white areas. As you assign each map, display it in the viewport with the Show Standard Map in Viewport option so you can adjust tiling appropriately.

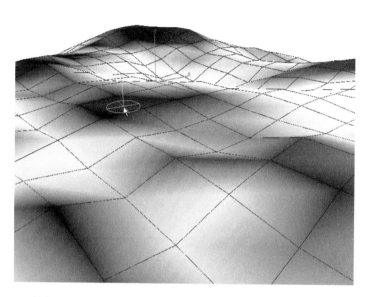

TerrainStart.max
TerrainMix.max

2 Make sure the color swatch in the Paintbox is black. Click the Paint tool and move the cursor over the object to see the disk-shaped Paintbrush tool. Drag the cursor over the object to paint areas black. Here, I've painted the peaks black and left the valleys white.

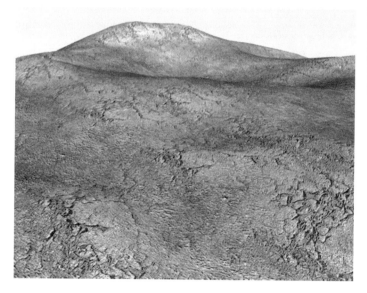

HOT TIP

To see the ground cover bitmap on the object without the vertex colors, turn on the Disable vertex color display option in the VertexPaint dialog.

4 For the Mix Amount map, choose a Vertex Color map. This will use the vertex colors to determine the amount by which the two maps are mixed. Since you can see only one map at a time in viewports, you'll need to render the image to see the result. You can also paint some of the black vertices back to white to change the effect.

89

Unwrapping the mapping

APPING A VERTICAL
surface like a
mountain presents specific
difficulties that can be solved
only with the Unwrap UVW
modifier.

This powerful tool can be
used in a variety of situations.
Here it's used to clean up
mapping artifacts on a vertical
surface.

Learning to visualize how
the Edit UVWs dialog relates to
the object takes some practice,
but it's well worth the time
spent. Once you know how
to unwrap your UVs, you'll be
able to map any object with
ease regardless of its size or
shape.

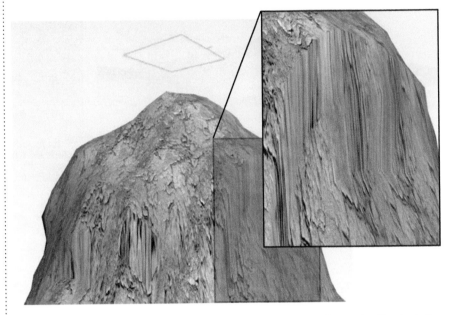

1 Planar mapping works fine for the top of the mountain, but you'll get stripes on the sides due to the map pixels going straight down. To visualize the problem clearly, you can apply a Checker map to the object and see where the checkers stretch.

4 For extreme vertical areas, you can also reduce the striping further by scaling selected vertices so they use more of the map. Turn on Soft Selection in the Options panel, and move and scale vertices. Vertices selected in the viewport are automatically selected in the Edit UVWs dialog, and vice versa.

MountStart.max
MountUVW.max

2 Apply an Unwrap UVW modifier and click Edit, and you'll see why. The vertices in the vertical areas are all bunched up around the center of the mapping coordinates. You'll use the Relax tool to fix this.

3 Select all the points and choose Tools menu > Relax. Choose the Relax by Centers option with the Keep Boundary Points Fixed option turned on, and click Apply several times until the distribution evens out.

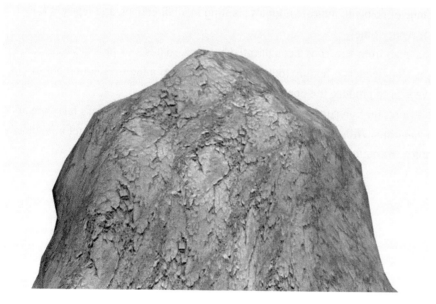

5 If the bitmap is displayed on the object in the viewport, you'll see it change interactively as you move vertices around in the Edit UVWs dialog. The result is a mountaintop with an evenly distributed texture and no obvious stripes due to mapping.

HOT TIP

You can display a bitmap in the Edit UVWs dialog to help you visualize how the map will fall on the object. If a material with a Diffuse bitmap has been assigned to the object, you can pick the bitmap from the dropdown list at the top of the dialog. You can also choose Pick Texture and pick a new one.

Normal mapping

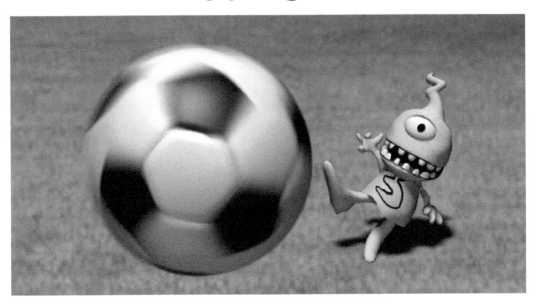

NORMAL MAPPING is a type of bump mapping that produces realistic, detailed bumps. Normal mapping is particularly useful for replacing a high-resolution object with a low-resolution version for medium shots and animation.

While bump mapping uses a grayscale image and distorts normals at render time, normal mapping uses a range of colors to indicate normals pointing in all directions, and replaces the normals entirely at render time.

Drawing a normal map from scratch is a complicated business, so 3ds Max provides tools to create them for you. The Render to Texture tool projects the faces of a high-resolution object onto a low-resolution version to produce the normal map.

Normal mapping works best on curved surfaces, where none of the hi-res object's faces are at right angles to one another. With the right kind of hi-res object, you can instantly get a fabulous-looking low-res object without the overhead of hi-res polygons.

5 In the Render to Texture dialog, in the Mapping Coordinates group, choose Use Automatic Unwrap for the Object setting. Having the Render to Texture operation unwrap the mapping for you usually yields better results than using the existing mapping.

7 As long as we're rendering a normal bump map, we may as well grab the hi-res object's texture too. Click the Add button again, and choose DiffuseMap. Set the Target Map Slot to Diffuse Color, and set the map size to 2048x2048.

6 In the Output rollout, click Add and choose NormalsMap, and click Add Elements to add it to the output queue. Make sure the Target Map Slot is set to Bump. Set the map size to 2048x2048, and turn on Output into Normal Bump.

8 In the Baked Material rollout, choose Output Into Source and Keep Source Materials. This will cause the Render to Texture operation to automatically assign the new maps to the low-res object's material in their appropriate slots.

SoccerBall.max

1 Create two objects, one with a high resolution and all the contours modeled, and the other a low-resolution version of the same object. Both objects must have mapping coordinates. Apply a material to the low-res object.

2 Move the low-res object in such a way that the normals of the high-res object will project onto its surface. Here, I've reduced the radius of the low-res ball so it fits inside the hi-res one.

3 Select the low-res object. Choose Render to Texture from the Rendering menu, or press the shortcut key **O**. The Render to Texture dialog appears.

4 In the Projection Mapping group, click Pick, and pick the hi-res object. This adds the Projection modifier to the low-res object, and puts a cage around the hi-res object. This cage sets the direction of the face projection from the hi-res to the low-res object.

HOT TIP

A *normal* is an imaginary vector (arrow) pointing out from a face or polygon. 3ds Max uses normals to determine how to shade surfaces at render time. For example, if a face's normal is pointing right at a light source, that face will render brighter than faces with normals pointing in other directions.

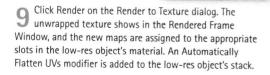

9 Click Render on the Render to Texture dialog. The unwrapped texture shows in the Rendered Frame Window, and the new maps are assigned to the appropriate slots in the low-res object's material. An Automatically Flatten UVs modifier is added to the low-res object's stack.

10 Move the low-res object away from the hi-res one, and render any viewport. The low-res object's material has been updated with the new maps, and it appears with the same colors and contours as the hi-res object.

Mapping a character

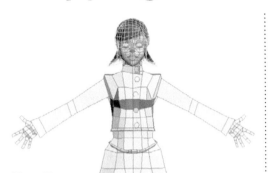

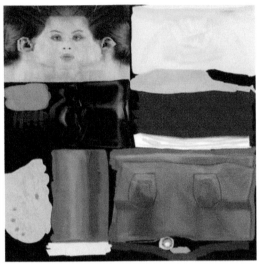

MAPPING A CHARACTER requires a few special techniques. The use of the Unwrap UVW modifier makes it possible to put all the textures into one image, making a game-ready character that uses as little memory as possible.

Wrapping your head around the Unwrap UVW modifier takes a little practice, but it will open up a new world of texturing to you.

1 Put all the various textures for the character in one square image. Create a material with this image as the Diffuse map.

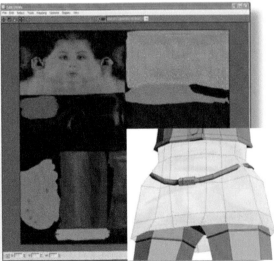

6 Apply the Unwrap UVW modifier, and click Edit. The mesh displayed in the Edit UVWs dialog represents the skirt flattened out. Choose the texture map from the dropdown at the top of the dialog to display it in the window.

7 Select all the vertices in the window. Using the transform tools at the upper left of the dialog, move and scale the vertices to fit the part of the texture they correspond to. In this case, it's the rectangular patch of green at the upper right of the texture image.

2 Select a body part to start mapping. In this case we'll start with the skirt. Select the polygons that make up the skirt, making sure you get all the ones around the back.

3 Apply the material to the selected polygons. The material won't look right, but that's okay at this stage.

GreenGirl.max

4 With the polygons still selected, apply the UVW Map modifier. Choose an appropriate map type, in this case Cylinder. Use View Align and Fit to fit the gizmo.

5 Choose Thick Seam Display in the UVW Map modifier panel to see where the gizmo's seam is. At the Gizmo sub-object level, rotate the gizmo to put the seam at the back.

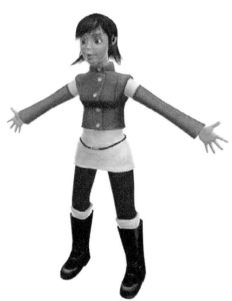

HOT TIP

To make the map easier to see and work with in the Edit UVWs dialog, choose Options > Preferences, turn off Tile Bitmap, and use View > Show Grid to turn off the grid display.

8 Collapse the modifier stack to set the mapping. Repeat the process for each part of the body, selecting polygons, choosing an appropriate UVW Map type for that section, and applying an Unwrap UVW modifier to align the mesh with the texture in the Edit UVWs dialog. When you select a vertex in the Edit UVWs dialog, it turns yellow on the mesh. You will see the mapping change on the character in the viewport as you move and scale vertices in the Edit UVWs dialog. Collapse the stack after aligning each part of the mesh in the Edit UVWs dialog.

Basic mental ray materials

MENTAL RAY comes with a number of preset materials that work "as is" in your scene. Materials that are difficult to create with the Standard type take just minutes when you use the Arch & Design material's presets.

Mental Ray materials are available only when Mental Ray is selected as the renderer. These materials are designated in the Material/Map Browser by a yellow sphere icon.

Note that if you switch back to the default renderer after you assign Mental Ray materials, you will need to reassign non-Mental Ray materials to make the scene render properly.

1 In the Render Setup dialog > Common tab, change the renderer to Mental Ray. Open the Slate Material Editor, where the Mental Ray materials will now be available. Drag an Arch & Design material into the Active View.

3 Experiment with more templates, and note how they change the Diffuse, Reflectivity, and Transparency settings. Also, look for the Bump and Displacement settings in the Special Purpose Maps rollout. Many templates automatically assign textures to these parameters.

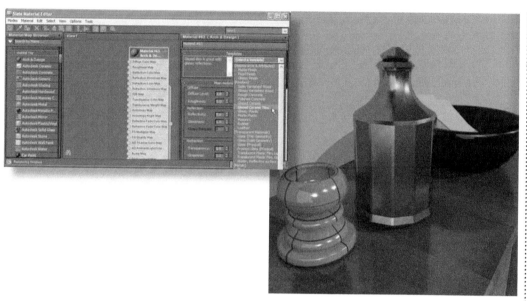

MRTable.max

2 Double-click the material node to see the material parameters. To get started, choose a template from the Select a Template dropdown and assign the material to an object in the scene. Choosing a template sets the material parameters to appropriate values, but the preset name doesn't stay with the material. Try a new template, change the Diffuse color swatch, apply it to an object, and render. Set the output resolution low to keep the rendering time reasonable.

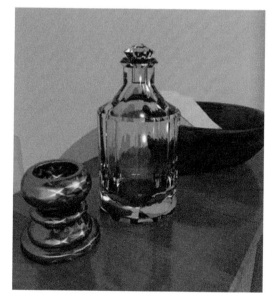

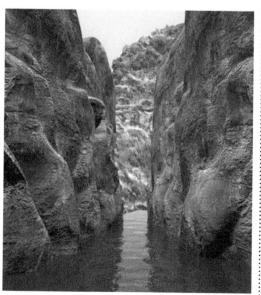

4 Where Mental Ray really shines is with hard-to-get-right materials like glass. Here, I've applied the Glass (Physical) template to the bottle. At any time, you can change the parameters on any rollout to change the object's color or appearance.

5 The Water, Reflective Surface template gives you instantly believable water. With just a quick change of the Diffuse color, you can make it match your scene. In the next topic, Custom Mental Ray Materials, you'll learn how to use your own maps with these templates.

HOT TIP

To keep the rendering time to a reasonable length while getting the benefits of Mental Ray, turn on Enable Final Gather in the Indirect Illumination tab of the Render Setup dialog, and set the Preset to Draft.

Custom mental ray materials

WHILE PRESET MATERIALS can get you through some of your projects, to really make use of Mental Ray you'll need to use your own bitmaps and textures. To create a 3D version of this 17th-century ornamental carving, I used Mental Ray to make all those nooks and crannies really pop.

1 Before you start using Mental Ray, create Standard materials for the object as usual.

4 Remove the default map assigned to the Arch & Design material by selecting and deleting it. Connect the Diffuse Color map from the original material to the Diffuse Color map for the Arch & Design material. Render the scene to see how the material is coming along. Here I've assigned the material to the leaves only.

5 Replace the Reflection Color map with the same map as the Diffuse map. In the case of Masonry, this will put soft reflections on the object. Replace the Bump map with your original material's bump map. For my model, the bumpiness was a bit high for the leaves, so I reduced the Bump value from 1.0 to 0.6.

2 Get the maps and materials to the point where the rendering looks pretty good with the default renderer, then assign Mental Ray as the current renderer (Render Setup dialog > Assign Renderer rollout). In the Indirect Illumination tab, turn on Enable Final Gather and choose the Draft preset. Render the scene to see if it looks any different. Shown here are renderings with the default renderer (top) and Mental Ray renderer (bottom). Aside from slight differences in shadows, you won't see much of a change until you assign Mental Ray materials.

Carving.max
CarvingMR.max

3 In the same Material Editor view, create a new Arch & Design material. This type of material, which is available only after you have set the renderer to Mental Ray, comes with a number of presets that make it easy to get a particular look for your materials. Click the Templates dropdown menu and choose a template. For my carving, I chose Masonry. Choosing a template changes the material parameters and assigns default maps automatically. You will make your custom material by replacing the default maps.

6 Use the same method to create Mental Ray materials for all other parts of the model. Use an appropriate preset as a base for each material, and replace the maps with your Standard material maps as necessary. Assign each material to a Polygon sub-object selection to automatically create a Multi/Sub-Object material made up of Mental Ray materials. Here, I've used the Vertex Paint method to make a messy wall with the Gradual Mix technique.

7 You can also use the bump map as a Displacement map. This causes the bumps to look as though they are physically modeled, so they show in profile in the rendering. Note the difference in the circular center of this model, where the ridges stand out and prevent it from looking perfectly round. I also made it look like an old relic by mixing a bit of the Speckle map with the original bump map and by applying a Noise modifier to the model itself.

HOT TIP

If a bump map creates too hard a line between black and white areas in the rendering, increase the Blur value on the bitmap's Coordinates rollout.

99

Lumps, bumps, and dainty curly stuff

WHEN YOU'RE MODELING an object that has lots of creases, crevices, and curlicues, a question arises: what parts do you model with polygons, and what parts do you represent with maps?

To answer this question, we'll look at an ornate mirror that I photographed at my friend's house. (Yep, that's me in the mirror with the camera.) My friend has a lot of cool antique stuff, and when I saw this mirror I knew I had to model it in 3ds Max.

The first step, of course, was to remove the background (and my face) and make a nice, clean texture map. Since the mirror frame is white, the image can work as both a texture map and a bump map. Then I painted over the frame with white to create an opacity map.

Rather than model each curlicue in the mirror frame, the texture/bump map can provide this detail. But what about the outer edges? The easiest approach is to map the image onto a box using the opacity map. However, the result is a flat-looking object. While the curlicues themselves look fine, you can tell from the edge of the object that it's flat.

MirrorThick.max

To get some thickness around the edges, I took a plane with 20x20 segments and pushed and pulled the vertices to make the mirror frame outline, then applied the Shell modifier to make it a 3D object. The TurboSmooth modifier with Iterations of 2 smoothed out the mirror frame nicely. (To understand why I didn't just draw a spline and extrude it, see How to Make a Mess with Modeling in the Modeling chapter.)

I also modified the opacity map to be solid (white) around the edges of the mirror frame. With this setup, the model has a bit of thickness around the edges, and all the curlicue detail is still provided by maps.

The same rules can be applied to any object. Interior detail: use maps. Exterior edges: use modeling.

■ In the first image, the objects appear to hover above the ground, and it's hard to tell how far apart they are from one another. Shadows ground the objects and clarify their relationship in the scene.

4
Lighting & shadows

LIGHTING AND SHADOWS ADD REALISM to a rendering,
but their purpose goes beyond making a scene believable.
Shadows anchor stationary objects to the ground and give
flying objects their height. They also give important visual
cues about scale and location, object solidity, and time of
day.

Once you determine the types of shadows you want to
have in your scene, you can choose from a variety of
methods to create them. Unfortunately, the best-looking
shadows usually take the longest to render. In this
chapter, you'll also learn some time-saving methods for
realistic shadows.

10.1016/B978-0-240-81433-9.50005-2

1-2-3 lighting

FOR GENERAL LIGHTING, a three-point or four-point system with Standard lights provides general illumination without washing out your scene. 3ds Max lights default to the Photmetric type, so you'll need to pick Standard from the dropdown menu before getting started.

A light's intensity is set by its Multiplier value in the Intensity/Color/Attenuation rollout. You can also change it in the Light Lister dialog, available from the Tools menu.

Use the top view of this classic lighting setup (shown at left) and angled view (shown on the right) to guide you in placing lights.

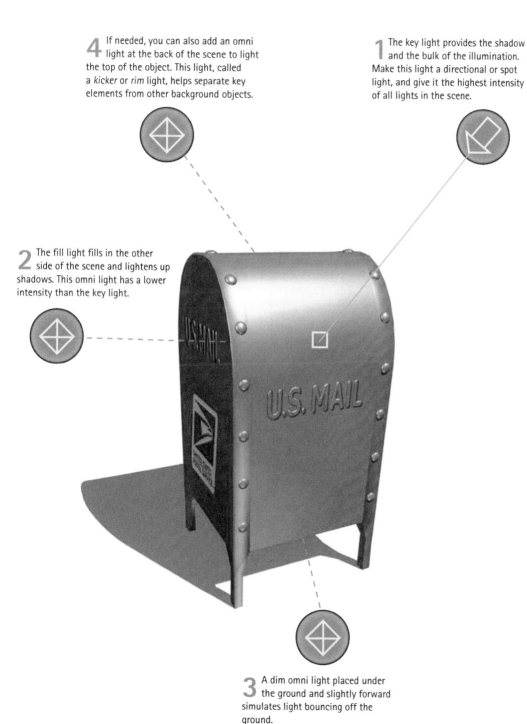

4 If needed, you can also add an omni
light at the back of the scene to light
the top of the object. This light, called
a *kicker* or *rim* light, helps separate key
elements from other background objects.

1 The key light provides the shadow
and the bulk of the illumination.
Make this light a directional or spot
light, and give it the highest intensity
of all lights in the scene.

2 The fill light fills in the other
side of the scene and lightens up
shadows. This omni light has a lower
intensity than the key light.

3 A dim omni light placed under
the ground and slightly forward
simulates light bouncing off the
ground.

Mailbox.max
MailboxLit.max

Exterior lighting

LIGHTING FOR AN outdoor scene requires a direct shadow-casting light to simulate the sun, a medium-strength fill light to lighten the shadows, and a dim underground light to simulate bounced light.

This lighting setup works equally well with the default renderer and with Mental Ray.

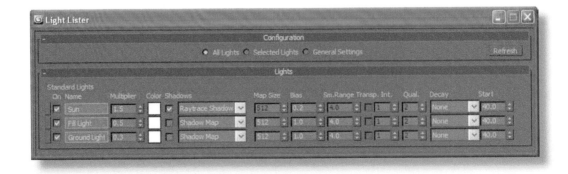

1 A strong direct light provides sunlight and shadow for the scene. Ray traced shadows simulate the sharp shadows of daylight.

2 An omni light opposite the main light fills in the shadows and simulates ambient light.

Exterior.max
ExteriorLit.max

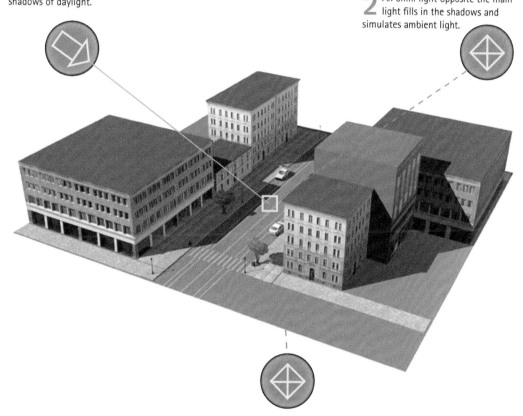

HOT TIP

While Ray Traced Shadows cast sharp shadows, Shadow Map shadows cast soft shadows like those you see on an overcast day.

If you're feeling adventurous and want to try out the Mental Ray renderer, use a mr Daylight System as the only light and see what kind of results you get.

3 A dim underground light provides the effect of light bouncing off the ground to illuminate overhangs and eaves.

Interior lighting

THE BEST WAY to simulate interior lighting is to place lights at actual light source locations. Shadow-casting spot lights provide the main illumination, while a few omni lights fill in the rest.

When placing multiple lights from the same type of light source, copy the lights as instances so you can adjust them all at once. In the Light Lister dialog, instanced lights show up as a single light with a dropdown menu.

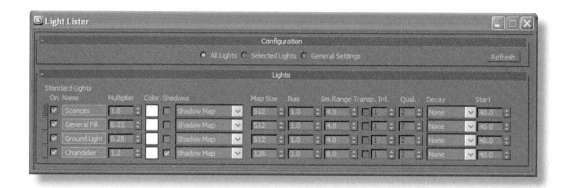

1 Place a shadow-casting spot light at each different type of ceiling light or lamp.

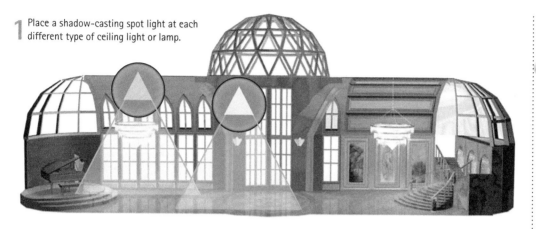

Interior.max
InteriorLit.max

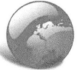

2 Create instances of the lights that repeat within the scene.

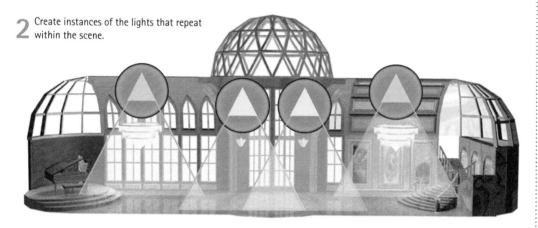

3 Add one or two omni lights to fill in the dark spots. Place an extra omni light underneath the structure to illuminate the ceiling and any overhangs.

Bright sunshiny day

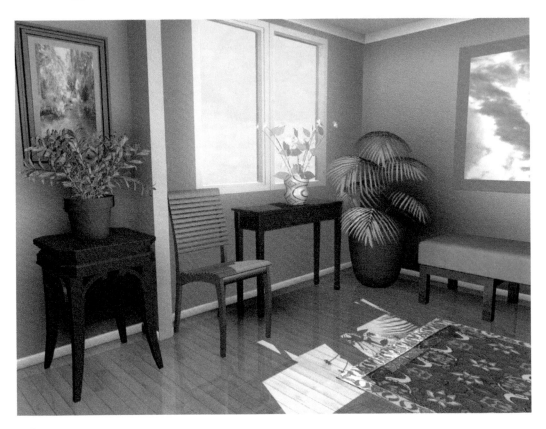

S UNLIGHT THROUGH a window makes a pretty presentation for a room. A glow around the windows simulates the real-life effect of light spilling in through the window and washing the outdoor view to white.

This topic shows how to set up this type of lighting for the default renderer. See the Mental Ray Lighting cheat for details on how to adjust it for Mental Ray.

1 Use a strong Direct light to make sunlight come through the window. Turn on Shadows and set the shadow type to Ray Traced Shadows. Turn off the Casts Shadows property for the window panes to allow the light to come through the windows and shine onto the floor.

2 Two or three Omni lights placed in the central part of the room simulate sunlight bouncing off the walls and floor to illuminate areas that aren't in the direct path of the sunlight. Turn on Shadows and set the shadow type to Shadow Map. A small Size and a large Sample Range create soft shadows on the walls and floor.

InteriorDay.max

HOT TIP

Shadow Map shadows from an Omni light get softer when you move the light farther away from the object receiving the shadow (wall or floor).

3 A glow around the windows adds to the impression of strong sunlight. Change the window pane material's Material ID Channel to a number other than 0, then set up a Glow with Render > Effects > Lens Effects. In the Glow Element rollout, go to the Options tab and set the Material ID value to the same number as the Material ID channel. Adjust the Intensity and Size parameters on the Parameters tab to make a soft glow around the windows in the rendering.

111

4 Lighting & shadows
Space scenes

OUTER SPACE is an unusual place with regard to lighting. The nearest star provides a strong light source, while distant stars and any lights from man-made starcraft make a negligible dent in the immediate scene.

The fact that very few people have actually seen outer space means you have a certain amount of freedom in your representation. That said, you won't go wrong by sticking to the lighting setup shown here. The strong light and deep shadows convey the mystery and majesty of outer space while remaining true to video footage from the space shuttle. If you want to add a few earthbound special effects like lens flares and glows, see the Good Lighting Made Better topic in this chapter.

In the rendering shown, a slight blur has been applied to the distant planet to indicate its distance from the camera. See the Depth of Field topic in the Rendering chapter to create this effect. To learn how to make the space background with mapping, see the Procedurally Speaking topic in the Materials and Mapping chapter.

1 Create a shadow-casting Direct light just for planets and other heavenly bodies. The light should come from the direction of the nearest star, wherever you decide that is, and its light cone should encompass just the planets and not your foreground elements. Increase the Multiplier to get a strong contrast between the daytime and nighttime sides of the planet, and set the shadow type to Ray Traced Shadows.

SpaceLit.max

2 Create a second shadow-casting Direct light just for foreground elements, with the shadow type set to Ray Traced Shadows. This will allow you to adjust the Multiplier separately for this light. The light's direction should match the heavenly bodies' light exactly.

HOT TIP

Make the light cone as small as possible while still illuminating the elements in the scene. The larger the light cones, the longer the render time will be.

Mental ray lighting

THE KEY TO GOOD LIGHTING with Mental Ray is to start with lighting that works well with the default renderer. Then you can switch to the Mental Ray renderer and adjust your lighting before moving on to adjusting materials. This usually means turning lights off or reducing their intensities rather than adding more lights to the scene.

To change the renderer to the Mental Ray renderer, choose Rendering menu > Render Setup > Common tab > Assign Renderer rollout, and pick the Mental Ray renderer. Then turn on Enable Final Gather in the Indirect Illumination tab, and set the Preset to Draft. You can also increase Diffuse Bounces to 1 or 2 to brighten up dark areas.

3 For an interior with windows, you'll always need to change all Shadow Map shadows to the Mental Ray Shadow Map type to keep soft shadows in the Mental Ray rendering. Usually, the default settings for this shadow type will give you harsh and blocky shadows, and even strange artifacts such as those on the tapestry on the far wall.

4 To fix the Mental Ray Shadow Map shadows, start by increasing the Sample Range in the Mental Ray Shadow Map rollout for both lights, which will spread out each shadow over a wider area. Here, I've increased the Sample Range to 0.2 for both lights. The result is a spray of dark dots on the walls, but we can fix that.

1 With an exterior scene, the change to Mental Ray lighting takes just a couple of minutes. You might need to decrease the lights' Multiplier values to get the right intensity or turn them off altogether. Here, I've turned off the underground light and reduced the Multiplier for both the sun and fill lights.

ExteriorMR.max
BallroomMR.max
RoomMR.max

When you render a Mental Ray scene that contains a glow, you might get an error message. Just click Continue, and the glow will appear in the rendering regardless of what the error message says. You can also use a Glare Output map to bloom the hotspots in the image.

Instead of adjusting light intensities, you can also try setting the exposure in the Environment and Effects dialog under Environment > Exposure Control.

2 Interior scenes are often just as easy to change over to Mental Ray. If most of your lights are instanced, you can reduce the Multiplier for several lights at a time. For an easy transition, set all shadow types to Ray Traced Shadows. The image at left shows the scene rendered with Mental Ray, with Standard materials and the lights dimmed by about half their original intensities. At right, most of the materials have been changed to Mental Ray materials, and the lights are at the same intensities as they were for the default renderer.

5 To smooth out the spotty shadows, increase the Samples value for each light to a high number such as 100 or 200. This will take color samples from more pixels in each shadow, effectively smoothing them out. It's a lot easier to make these adjustments at the very start, before you adjust Multiplier levels.

6 Before making further adjustments to lights, change your materials to Mental Ray materials, as described in the Custom Mental Ray Materials topic in the Materials and Mapping chapter.

Good lighting made better

LIGHTING EFFECTS can add that extra something to a scene. The techniques shown here are good choices if you need to punch up the scene or give it a bit of interest. However, these techniques are not a substitute for good basic lighting.

As with all good things in 3D, enhancements can take longer to render but can set your image apart from the crowd.

2 Changing the color swatch in the Intensity/Color/Attenuation rollout changes the light's color. For outdoor scenes, use pale yellow for sunlight and pale blue for moonlight.

4 Lens flares, in real life, are the result of dust on the lens interacting with strong light. Set up this type of effect on the Effects tab of the Environment and Effects dialog by adding Lens Effects and making an omni light the source of the effect.

RoomNeg.max
RoomAtten.max
SpaceFlare.max
RoomVolume.max

1 A negative Multiplier value decreases the lighting where the light shines, creating a dark spot. Use this technique when you want to reduce light in a small area. You can also scale the light itself on one axis to shape the light to the area you want to affect. Here, a spot light has been scaled on one axis to make its hotspot and falloff areas tall and thin.

3 Attenuation causes a light to lessen or decay farther from the light source. Turn on this feature for an individual light with the Use checkbox in the Far Attenuation group. To control the degree of decay, turn on Show and adjust the Start and End values. The image at left has no attenuation, while the image at right has attenuation enabled for the two omni lights that simulate bounced light. The effect takes longer to render but can add a touch of realism to your lighting.

5 A volume light is suitable for strong sunlight through a window mingling with dust or smoke. To create this effect, choose Rendering > Environment, click Add, pick Volume Light, and pick the light. For the light itself, turn on the two Use checkboxes for the light in the Intensity/Color/Attenuation rollout and adjust the Near and Far values to prevent the volume light from overpowering the scene. You can also change the Density and Max Light % values in the Environment rollout to change the "thickness" of the effect.

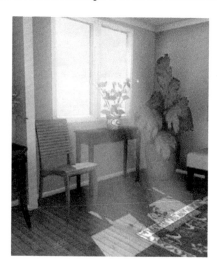

117

Daylight savings time

IN RESPONSE TO user requests, Autodesk has introduced several lighting systems into the last few releases of 3ds Max. The advantage is more choices for you. The disadvantage is that older systems are never retired, and the plethora of choices can be confusing.

This guide takes you on a tour of the Daylight lighting system and its uses. The Daylight lighting system, designed for use with Mental Ray, sets a light to use as a virtual sun and an environment or background for a virtual sky, which not only renders in viewports but affects the coloration of the scene.

The Daylight system features a compass rose and date/time/location settings for real-life light settings, but you can also adjust the light angle manually. The Daylight system is the only place where you can enable the mr sun light, which works like Skylight but is optimized for Mental Ray. While the mr sun can save time in some situations, standard lighting is still just as useful as it always has been.

It's best to use the Daylight system with scenes that are created to real-world scale. You can use it with all scenes, but you might need to make heavy use of Multiplier parameters to get the right lighting.

1 To create a Daylight system, choose Create > Systems > Daylight and drag in any viewport. Drag once to create the compass rose, and then again to set the height of the light. To adjust the light's distance from the scene, choose Date, Time and Location, and change the Orbital Scale value. You can switch to other types of lights and skies on the Modify panel.

4 If you need a photographic background with the Daylight system, you're best off using the map itself as the background in the Environment and Effects dialog rather than mr physical sky. Select the Daylight, and in the Modify panel, set the Skylight option to Skylight rather than mr sky. This uses settings in the Skylight Parameters rollout to illuminate the scene, even if you don't have a Skylight in the scene.

2 The mr physical sky map is a partner to the Daylight system. It creates a basic simulation of the sky not so much for a pretty rendering but to give the mr sun light some color to work with for reflectivity. When you choose mr sky as the Skylight, the Daylight system automatically creates this map and sets it as the background in the Environment and Effects dialog (provided there isn't already a map there). You can drag the map from the dialog to the Material Editor to see and edit its settings. To see exactly how the sky will turn out in viewports, turn on Hardware Shading for the viewport (*Shift* *F* *3*).

3 The mr physical sky map displays some basic colors that you can adjust in the Material Editor. If the sky is black, try increasing the Multiplier in the mr sun light's mr Sky Parameters rollout. You can also add some indistinct clouds or color to the mr physical sky map by turning off Inherit from mr sky in the Material Editor and assigning a bitmap to the Haze slot. For the bitmap, choose Environ and Spherical Environment, and increase the Output Amount to 5-10 and RGB Level to 2-3.

5 If you use mr sun with mr physical sky and the mr sun light is visible in the rendering, the sun will appear in the rendering. There's limited use for this feature, but it is very cool.

HOT TIP

The Skylight light can also create realistic diffuse lighting throughout a scene, but it's designed to work with the Default Scanline renderer; you can't get shadows if you use it with Mental Ray. Skylight was originally designed to work with Light Tracer, an early raytracing tool that has been largely replaced by Mental Ray.

How to waste time with lighting

IF YOU'VE GOT a lot of time to kill, I can recommend a few ways to spend it. Here are some tried-and-true ways to spend hours and hours on your lighting without improving it at all.

The first one goes something like this. The rendering doesn't look so good, so you add more lights. Then it looks even worse, so you add more lights. Before you know it, you have a scene that takes five times longer to render than the one you started with, it doesn't look any better, and you have a mess of lights that are becoming more confusing by the minute.

If your lighting isn't behaving, the solution is usually fewer lights, not more. Sure, if it all looks perfect except that one little corner, you might add another fill light to brighten it up. But that's improving good lighting, not trying to fix bad lighting with more and more lights.

When the rendering doesn't look good, step back and consider what's missing. If you've got plenty of lights in there and it's still too dim, an object in the scene might be blocking a shadow-casting light. Use the Light Lister dialog to turn off all your shadows and try it again. If it's too bright, the answer is obvious: turn down the Multiplier for some of the lights. In general, if you have to set a Multiplier to more than 2.0, something else is wrong.

If the scene is nicely illuminated but still looks blah, look at other tools for improving it. Does the scene need reflections or shadows to spruce it up? Are your materials flat, boring, or downright ugly?

Another time-killer is the use of Mental Ray to "fix" bad lighting. Sorry, but it doesn't work that way. Your lighting needs to look good in the default renderer in order to look good in Mental Ray. But don't take my word for it—go ahead and do a few long renderings to use up all that free time you have.

As with all aspects of 3D, your best reference is the real world. Need outdoor lighting? Look out the window. Look at the reflections, the shadows, the difference between colors in direct and indirect light. These will give you clues as to where to place your fill lights.

Photographs can also be helpful, especially pretty pictures taken by professional photographers. If you're doing interiors, look for photos at websites that sell home furnishings. What kind of light pattern does a lamp shade make on the wall when the light is turned on? Can you actually see under the sofa, and do you want to?

And lastly, the most common mistake I see in new users is an overwhelming zeal for lighting every little nook and cranny of the scene. A beautiful rendering has areas of contrast, light and shadow, dim corners, and variations in light across large surfaces.

So if you're not interested in wasting time, stick to the basics. Put three or four lights in the scene, get it reasonably well-illuminated, then look at simple ways to simulate real life with an extra light here or there. Then call it a day, and spend your time doing something else.

Pick your shadows

S HADOWS CAN BE sharp or fuzzy, light or dark. Regardless of the renderer you use, most shadows come in one of two flavors:

Ray Traced Shadows cast sharp, accurate shadows.

Shadow Map shadows can be sharp or fuzzy, depending on your settings.

There are other types of shadows available in 3ds Max, but these are the types you'll use most often.

1 With no shadows in the scene, the objects appear to float above the ground. Turning on shadows by checking the On checkbox in the Shadow group for your main light will cause shadows to appear.

2 In life, soft shadows are the result of light bouncing around, effectively creating millions of pale light sources. Examples are indoor lighting, which bounces many times around a room, or overcast daylight, which bounces in the clouds before coming down. For this effect, use a Shadow Map with a low Size and high Sample Range. Note that Shadow Map shadows don't work with Opacity maps.

3 Sharp shadows indicate objects close to the ground in a hard light like sunlight. Ray Traced Shadows always produce sharp shadows. You can get a similar effect in less rendering time with a Shadow Map with the Size parameter set to a high value. However, the only way to get shadows from an Opacity map is to use Ray Traced Shadows.

HOT TIP

If you're not sure what types of shadows to use in your scene, find a photograph with lighting similar to your scene's lighting and create the same kinds of shadows in your scene. Ten minutes of research can save you hours of trial and error. Try Google Images and search with general keywords like *street scene, living room,* or *outer space.*

123

4

Shadow timesavers

RENDERINGS WITH LOTS of detailed shadows can easily take five to ten times longer to render than simpler scenes. Use these timesavers to reduce rendering time without sacrificing scene quality.

1 When a complex object needs just a simple shadow, you can place a simplified copy of the object in the same spot and use its shadow instead. Here, a sphere with the Noise modifier applied to it and a tapered cylinder stand in for the tree. Turn off the Cast Shadows property for the complex object, and for the simple objects, turn off the Visible to Camera property.

2 You can create a fast-rendering shadow using a light with a negative Multiplier value. These "blob" shadows render much faster than ordinary shadows, making them a favorite for background elements such as cars, trees, and distant buildings. In the rendering shown, the shadow under the mailbox comes from a rectangular spot light with the Multiplier set to -0.6, a value that makes the mailbox shadow match the intensity of the lamppost shadow. Using the Scale transform, I scaled the light on one axis to make its beam match the mailbox's actual shadow shape, and I added a Skew modifier to the spot light itself to skew the light beam in the correct direction. The light's falloff angle is about 50% larger than its hotspot, giving the shadow a soft edge. The spot light affects only the sidewalk, and the mailbox's Casts Shadows property is turned off. The diagram shows the spot light's skewed falloff and hotspot in relationship to the mailbox from the Top view.

3 To cast additional shadows without adding objects to the scene, assign a black-and-white map as a projector map on the light's Advanced Effects rollout. A map used in this way is called a *gobo*. Shown are the original photo of a tree's shadow on concrete (top left) and the cleaned-up image used as a gobo (bottom left). The impression of shade from a nearby tree is achieved with no added geometry.

Where's the shadow?

SHADOWS HAVE A HABIT of disappearing from time to time. Described here are the top five reasons your shadows aren't appearing in your scene.

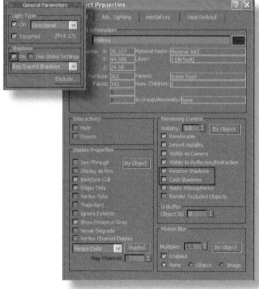

1 Make sure the Shadows option is turned on for the light, and that each object's Cast Shadows and Receive Shadows properties are turned on (Edit > Object Properties).

4 Light that you expect to show through an opening, such as light through a window, might be blocked by an object. Turn off the object's Cast Shadows attribute to let the light shine through.

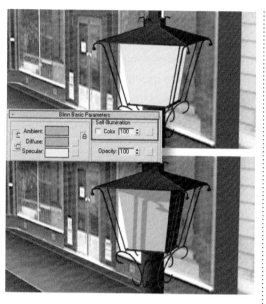

2 If the other lights are too bright, shadows can be washed out. The shadow-casting light should be the brightest, and the total of all Multipliers should be below 3.0.

3 If the object receiving the shadow is completely self-illuminated, no shadow will appear. Turn down the material's Self-Illumination value in the Material Editor.

5 If the light angle is too low in relation to the surface receiving the shadow, the shadow might stretch out or might not even appear at all. Move the light up to increase the angle to the ground.

HOT TIP

If you're having trouble determining what the problem is with your shadows, turn off all the lights, and then turn them on one by one and render the scene. The Light Lister dialog is an excellent tool for this trouble-shooting technique.

Troubleshooting shadows

S O YOUR SHADOWS ARE appearing, but they're misbehaving. If you don't know why they're being naughty, you can waste hours trying to make them obey. Check out these common shadow problems and their solutions.

1 If visible rectangular chunks appear in a Shadow Map shadow, you need more samples. Increase the Sample Range for the shadow to smooth them out.

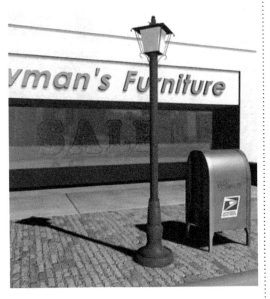

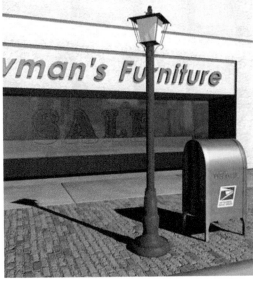

4 Spot and Omni lights cast non-parallel shadows (left). Compare with Direct lights, which cast parallel shadows like those from the sun (right). Non-parallel shadows make an outdoor scene look small, like a miniature indoor version. The difference is subtle, but the human eye can detect it.

2 Shadow Map shadows can sometimes appear to skip over parts of the model, creating rough shadow lines. Increase the shadow map's Size parameter.

3 Sometimes a shadow becomes disconnected from the object that casts it. This effect is most noticeable with thin objects. Reduce the Bias setting for the shadow type to bring the shadow closer to the object.

HOT TIP

A Shadow Map shadow works by projecting a square map in the direction of the light in the Size you specify. The larger the Size, the more shadow detail is calculated.

5 You can also preview shadows in a viewport if you have a Direct3D driver (as most computers do these days). First, check your video driver for 3ds Max to make sure it's set to Direct3D. To enable shadows in a viewport, click the Shading label, and choose Lighting And Shadows > Enable Hardware Shading. From the same menu, choose Enable Shadows to turn it on.

Shadow and wireframe presentation

YOU'VE PROBABLY SEEN images of models presented with a nice shadow beneath them or even a wireframe representation. These types of images have become a staple on the Web for modelers showcasing their work in portfolios, stock 3D model marketplaces, and online profiles. The techniques for producing these images aren't complicated but require a bit more thought than a simple rendering or screen capture.

For a model with a shadow beneath it, place a plane at the floor level (usually just touching the bottom of the model) and point a shadow-casting light at the model. Then create a Matte/Shadow material and apply it to the object. When you render, only the shadow cast by the object will appear on the plane, and the rest of the plane will be invisible.

Presenting a wireframe requires a little more ingenuity. You could just turn on the Backface Cull option on the Display panel and capture the screen, but in general this gives you a pretty ugly capture. On the dog model shown, for example, there's a lot of crisscrossing of edges on the belly, back, and head. This happens with just about any model that has any complexity to it.

You could also render the model with the Force Wireframe option turned on (Render Scene dialog > Renderer tab), but that will give you pretty much the same result.

Instead, create a copy of the model right on top of itself with Edit > Clone. Create two materials, one a Matte/Shadow material with the Receive Shadows option turned off and the other a black self-illuminated material.

Assign the Matte/Shadow material to the original and the black material to the copy. Select the copy and apply the Lattice modifier to it. This creates geometry along each edge. Choose the Struts Only From Edges option and reduce the Radius to a value that looks good. For the dog, I set the Radius to 0.5.

The Lattice technique is the most reliable, but it has a limitation: the wireframe will be narrower farther from the camera. For most models this isn't

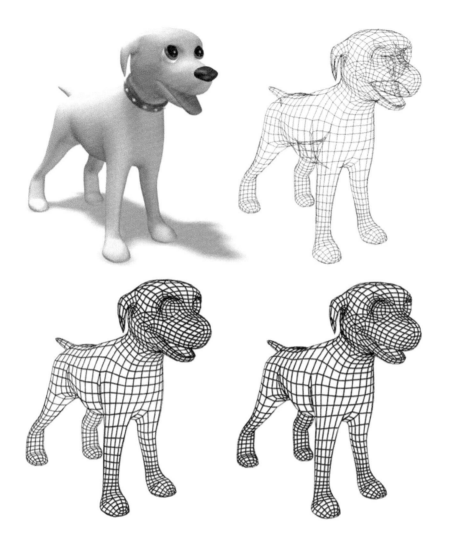

■ Dog model rendered with Matte/Shadow plane below it, followed by straight screen capture with Backface Cull (upper right), Lattice copy (lower left), and Push copy (lower right).

a problem, but if you prefer to have a uniform wire width, you can use the Push modifier instead.

Select the copy, and instead of applying the Lattice modifier, apply a Push modifier. Set the Push Value to a small number such as 0.2. This will push the model's faces out along their normals. Then, for the black material, turn on the Wire option. In the Extended Parameters rollout, set the wire's Size and turn on the Pixels option. The rendered image will have a uniform wire size everywhere in the rendering, regardless of the edges' distances from the camera.

In both cases, the key is the original object inside the copy with its Matte/Shadow material. This material hides the edges at the back of the model and does a far better job than a screen capture with the Backface Cull option.

■ Nothing says "shiny" like reflective surfaces in your scene. To get as much bling as you can with the least rendering time, use the techniques in this chapter.

5 Reflections

IN LIFE, REFLECTIONS APPEAR on shiny objects. A bit of shine and reflection well placed in a scene adds realism that you can't get any other way.

While nature produces reflections with ease, recreating them in 3ds Max takes some know-how. There just isn't enough rendering time in this world to render every reflection that nature makes, so you need to pick where and how your reflections will appear. Knowing your options and the end result you're looking for are essential to fast work and pretty results.

10.1016/B978-0-240-81433-9.50006-4

Reflecting on reflections

REFLECTIONS ADD a needed degree of realism to a scene. However, there's no magic Reflection button in 3ds Max; you need to set reflection types separately for each material used in the scene.

In general, the more accurate you want the reflections to be, the longer the effect will take to render. If an object is close to the camera or is the focal point of the scene, you'll need accurate reflections. For incidental objects, simpler and faster-rendering solutions will do.

Here, reflection techniques are presented roughly in order of fast/decent to slow/ accurate.

3 Using a Reflect/Refract map in the Reflection channel causes curved objects to reflect the environment, which means you need to have surrounding geometry and/ or an environment map to reflect. The Reflection percentage determines how strongly the surrounding geometry is reflected. Here, the ball and candy dish reflect each other as well as the environment.

4 While a Reflect/Refract map works fine for rounded objects, it won't generate accurate reflections on flat surfaces. For flat objects like the tabletop, use a Flat Mirror map in the Reflection channel, and apply the material to a set of coplanar (flat) polygons rather than the entire object. You can do this using the technique described in the Multiple Maps topic in the Materials and Mapping chapter.

CandyDish.max

1 The quickest and easiest reflective material for curved surfaces is a Standard material with a Bitmap map in the Reflection channel. This type of map puts a bitmap on an imaginary sphere around the scene and reflects the pixels off the object based on the camera angle. Here, I've used Chromic.jpg, a map that comes with 3ds Max and my favorite all-purpose bitmap for reflection.

2 By default, the Reflection percentage is set to 100 (represented as 1.0 in the Controller Bezier Float node), which causes the reflection to overpower the material. Reduce the percentage in the Maps rollout to 10 or 20 (or the Controller Bezier Float value to 0.1 or 0.2) and increase the Specular Level and Glossiness settings to make reflections more realistic.

HOT TIP

Many all-purpose reflection bitmaps are included with 3ds Max in the Maps/Reflection folder.

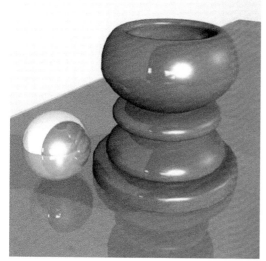

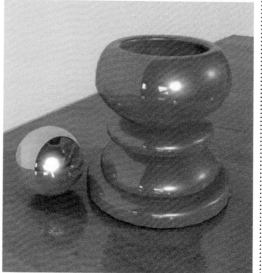

5 You can get slightly more accurate results with a Raytrace map on both curved and flat surfaces, but it takes much longer to render. This map was an older solution to the problem of reflections, which is why it's used in so many scenes from previous versions of 3ds Max. Raytrace maps can usually be replaced with Reflect/Refract and Flat Mirror maps without noticeable loss of scene quality.

6 Of course, you get the best results with Mental Ray materials, which automatically reflect the geometry and environment map if the Reflectivity setting is above 0.0. The reflectivity works for both curved and flat surfaces. However, the added render time is worth it only if the reflective objects are the focal point of the scene. Otherwise, you can use the faster, simpler solutions described in earlier steps.

Reflections

Bling

S UCH A BRILLIANT SHINE is easy to produce with the help of the Raytrace material and a
black-and-white background map. This type of material renders fast and produces great
results without the overhead of Mental Ray.

A few simple steps is all it takes. The resulting jewels will sparkle and shine regardless of the
lighting setup you use.

3 To make the bling sing, a black-and-white background is essential. Open the Environment and Effects dialog with
Rendering menu > Environment, and click the Environment Map box to choose a bitmap. Here I've used Chromic.jpg from
the standard Maps/Reflection folder. Drag the map from the Environment and Effects dialog to the Slate Material Editor as
an Instance so you can edit its parameters. In the bitmap's Coordinates rollout, choose the Environ option and the Spherical
Environment type to wrap the image around the scene. For this scene, I also cropped the bitmap to use mostly white areas.

Bracelet.max

1 To make the jewel surface, start with a Spindle, available as an Extended Primitive. Collapse it to an Editable Poly and weld the center vertices together.

2 Shape the spindle by welding vertices and chamfering edges as needed. Don't apply TurboSmooth, as the faceted surface will provide the shine.

HOT TIP

The Raytrace material is a legacy feature from many releases ago. Before we had Mental Ray, the Raytrace material was used to create most of our advanced reflection effects. Although Mental Ray materials have replaced the Raytrace material for most applications, it's still the best thing around for precious gems.

4 For the gems, create a new Raytrace material to apply to the spindles. Change Luminosity and Transparency to white, and experiment with the index of refraction (Index of Refr.). To enhance the gem's transparency, use a Falloff map in the Reflect channel with Falloff Type set to Fresnel.

5 To make a colored gemstone, set Luminosity to black, and change the Diffuse and Transparency colors to the colors of the gem. Change the Specular Color to a lighter version of the gemstone color, and adjust the index of refraction as necessary.

Mirror, mirror

FLAT SURFACES that need to appear shiny are easy to create when you have an environment to reflect. But often, you won't have enough geometry in the scene to offer a realistic reflection, or the reflection of the scene itself won't give you the look you want.

A bitmap in the Reflection channel might seem like the perfect fast-rendering solution, but you'll find that this type of reflection won't work with flat surfaces. You'll have to fool the renderer into thinking your surface is curved to get a reflection happening on your flat surface.

1 A mirror needs to reflect something to look like a mirror. Simply using a Flat Mirror map doesn't do the job. Since there's no environment to reflect, the mirror looks like an empty hole.

4 By using a Noise map in the Bump map channel, you can fool the renderer into treating the glass like a curved surface. The bump map doesn't affect the edges of the oval at all, only the appearance of the surface itself.

MirrorShine.max

2 Using a bitmap as an environment background gives you a reflection, but this works only if you want a background image and if there's nothing obstructing the mirror.

3 You could put the background bitmap in the Reflection channel, but since the mirror is flat, it reflects only one pixel from the entire image. This type of map works only if the surface is curved.

HOT TIP

To get just two or three bumps across the entire surface, increase the Noise map's Size parameter to a larger value.

5 With this fake bumpy surface, a Reflection bitmap picks up the reflection along with any highlights from light sources. The Specular Level and Glossiness need to be turned up to see the effect.

6 To make the reflection less distinct, increase the Reflection bitmap's Blur Offset parameter to a small value such as 0.1. Now the mirror looks as if it's reflecting some kind of environment.

Dude, where's my reflection?

SO YOU'VE SET UP A STANDARD MATERIAL for a reflective surface using a Reflect/Refract map or Flat Mirror map in the Reflection slot. You apply the material, render the camera view, and...nothing. No reflection on the surface. What went wrong?

The first thing to check is the material's Specular Level and Glossiness parameters, which control the material's shininess. If it ain't shiny, it won't reflect. Increase these parameters and see if that works.

If increased shininess doesn't do the trick, then the problem is most likely with the angles between the objects. To understand how this works, we'll do a quick lesson in optics, the science of light.

In life, light bounces off an object and into your eyes or a camera. Light bouncing off the object means you can see it; no light bouncing off the object means you can't.

When a mirror or other reflective surface is present, light bounces off the object, then the mirror, and then into your eyes. That's how you see the reflection in the mirror. The light always bounces in a straight line, and bounces off the reflective surface at exactly the same angle at which it hits it.

In order to see a reflection in a mirror, your eyes have to be at the same angle to the mirror as the object you're looking at. When you stand straight in front of a mirror, the light just bounces straight out and back again into your eyes. If you stand to one side of the mirror, you'll see objects on the other side.

When you're seeing a reflection, distance from the mirror is not a factor in whether the object is reflected; only the angle of reflection is important. If this is confusing, get out a hand mirror and experiment with it. Hold it to the side and see what reflects in the mirror, and compare your eyes' angle to the reflected angle.

And so it is in 3D. In order for the camera to "see" the reflection, the object being reflected on the surface must be at the same angle to the surface as the camera. If it isn't, you won't see a reflection.

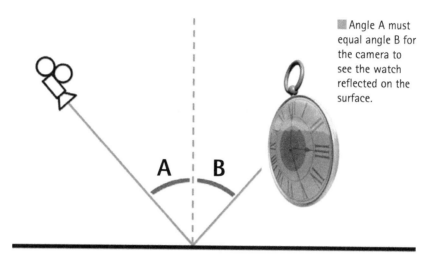

Angle A must equal angle B for the camera to see the watch reflected on the surface.

Highlights work the same way. A highlight is created by light reflecting off a surface and right into your eyes. Getting highlights on an object is a matter of placing the light in such a way that it bounces off a part of the object and right into the camera lens.

The Place Highlight tool, available from the Align flyout on the toolbar, works very well for both highlight and reflection placement. For a highlight, activate the camera view, select the light, choose Place Highlight, and drag the cursor over the shiny object. The light will move around to place the highlight at the cursor position. Release the cursor where you want the highlight to appear, and the light is placed in such a way that a highlight will be produced when you render.

To place an object to reflect on a surface, select the object that will be reflected, activate the camera view, and choose Place Highlight. Drag the cursor over the reflective surface and release the mouse when you reach the spot where you want the reflection to appear.

If you still don't get a reflection, then something else is wrong. Be sure to use the Reflect/Refract map on curved surfaces only, and the Flat Mirror map on flat surfaces only. You can also try working with a simplified version of the scene. Get the reflections to appear in the less complex scene, and then build it up gradually to the complex version.

141

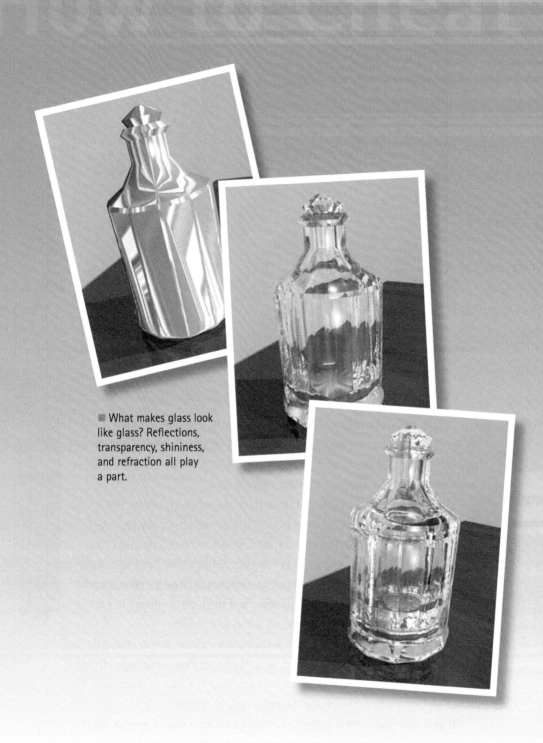

■ What makes glass look like glass? Reflections, transparency, shininess, and refraction all play a part.

6

Glass

GLASS CAN SEEM TO BE awfully complicated. Plain old transparency with a bit of shine doesn't do the trick. You search in vain for the Instant Glass button, but somehow the developers of 3ds Max left it out of the user interface.

The key is to use reference images to find the look you want, and then consider which maps and parameters will create a material that simulates that look.

10.1016/B978-0-240-81433-9.50007-6

Exterior daytime windows

GLASS WINDOWS ON A SUNNY DAY make a pretty architectural rendering. Using photos for reference, you can create a realistic rendition of windows seen from the outside, as with this rendering from Neoscape, Inc.

2 You can use a photo as a basis for a texture and map it onto the windows. This will give you a realistic look, but only if the light is coming from the same angle as in the photo. For a still image, this is a viable option. With an animated camera, the lack of a changing reflection will become obvious as soon as the camera moves.

1 From photos, you can see that exterior windows in daylight aren't really transparent. Depending on the lighting, you might be able to see partway into the building, or you only see a reflection of the environment.

3 To reflect the sky and also show shadows from the scene's light source, apply a Matte/Shadow material to the windowpanes. Be sure to turn on Receive Shadows and Additive Reflection for the material. If using Mental Ray, use the Matte/Shadow/Reflection (mi) material. Here, a large plane creates the panes for all the windows at once, and mullions are modeled separately to sit above the plane.

6 Glass
Interior daytime windows

THE APPEARANCE OF WINDOWS can make or break an interior rendering. Nicely done windows indicate a space with air and light. The appearance of the exterior environment through the windows coupled with the play of light on the floor will do most of the work for you.

1 Being able to see the environment outside indicates less direct light or a lower exposure for your virtual photograph. Here, there's no distinct light shape on the floor, but rather a blown-out highlight, indicating indirect light. This effect is created with a spot light that shines only on the floors and nearby walls, with a large difference between its Hotspot and Falloff angles. A hint of reflection in the windowpanes is appropriate for this type of setup.

DayClear.max
DayWhite.max

2 A higher exposure for your virtual photo almost completely whites out the environment in the windows. A sharp light shape on the floor indicates direct light coming through the window. Create this effect by whiting out the background and making the windows nearly opaque.

Nighttime and dusk

WINDOWS AT NIGHTTIME are perhaps the easiest to do. For exterior scenes, they're just clear panes showing the scene lit within. For interiors, the scene outside is dark, perhaps showing a brightly lit cityscape but not much else.

For exterior scenes at dusk, the appearance of windows varies according to the direction of the sun and also whether anyone has bothered to turn on the lights. The reference images shown above help show the various ways windows can look at these different times of day.

1 In late afternoon or at dusk, windows are dark if the lights aren't on and bright if they are. The direction of the sun is also a factor.

2 Nighttime windows are brightly lit from inside, and the interior is visible.

HOT TIP

For nighttime exteriors, you'll need to put something inside the building for the viewer to see through the window. Often, a few items mapped onto planes will do the trick.

3 Interior windows at night are dark, not allowing much of an exterior view. In the picture at right, a bit of the cityscape is visible.

Glass bottle

GLASS IS SHINY and transparent, so to make curved glass, all you have to do is turn up the shine and lower the opacity on the material, right?

Not exactly. Curved glass is refractive, meaning light bends as it passes through it. Refraction is one of the properties that distinguishes glass from plastic and other materials.

To make convincing glass, you actually don't mess with the opacity at all. Instead, you get refraction to do all the work for you. You can use the same technique to create drinking glasses, vases, and any kind of curved glass object.

1 Let's take a look at a few reference photos. The cut-glass vase refracts light aplenty, creating an irregular pattern of black and white reflections. In fact, there's so much refraction you can hardly see through it at all. Even a simple drinking glass refracts light to some degree.

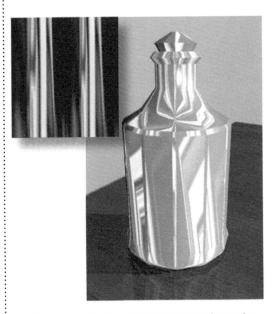

4 To save rendering time, you can get pretty decent glass with a Standard material. Start by setting up a streaky map as the Reflection map and giving the material high Specular Level and Glossiness values to make it shiny.

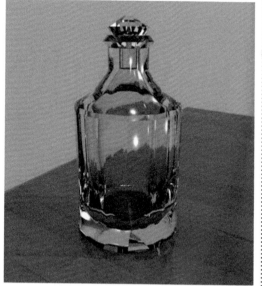

GlassBottle.max

2 To make convincing glass, model both the inside and outside of the object. To get the refractions that suggest cut glass, don't apply TurboSmooth. Keep the number of polygons low and assign facets to different smoothing groups to enhance the effect.

3 If you have plenty of time for rendering, you can use a Mental Ray material. Change the renderer to Mental Ray, choose the Arch & Design material, and choose the Glass (Physical) template. This material works right out of the box but takes longer to render than a Standard material.

HOT TIP

In 3ds Max, the appearance of a glass material changes in different kinds of light. Set up your lighting first before spending a lot of time getting the glass to look right.

5 To get refractions, add a Raytrace map as the Refraction map. Lower the Reflection map percent to 10 or 20. Because the Refraction map creates the illusion of transparency, you won't need to adjust Opacity at all.

6 Change the Index of Refraction in the Extended Parameters rollout to get different effects. Here, I've set the Index of Refraction to 2.5 and Reflection map percent to just 10.

Fun with physics

BEHOLD THE HUMBLE drinking glass. You've seen a glass like this a hundred times, so you know what it should look like, right? Unfortunately, so does everyone else. This means you can't get away with a cheesy rendering of a transparent tube. A little physics is required to get a realistic rendering.

To study the properties of curved glass, I placed a pencil into an ordinary drinking glass. As light passes through the glass, it bends, bounces around a bit, and eventually makes it into your eyes (or in this case, the camera lens). The picture at the far left shows the actual photograph, where the pencil inside the glass appears bent.

Modeling the glass, pencil, and tabletop in 3ds Max was a pretty simple exercise. I used Bevel on each of the polygons in the middle portion of the glass to simulate the indentations in the glass I photographed, and I made a custom texture to simulate the spots on the glass.

Next up was the material for the glass. In life, some transparent media, such as glass and water, bend light to some degree. In physics, this degree is expressed as a number called the Index of Refraction. Plain old air, which doesn't bend light at all, has an Index of Refraction of 1.0. Numbers greater and lesser than 1.0 indicate bending of light. The farther you get from 1.0, the more the light bends. Numbers less than 1.0, such as 0.8 and 0.9, bend the light one way, while numbers such as 1.1 and 1.2 bend it in the other direction.

■ The first image shows a photo of a pencil in a glass. The rest of the images are renderings, with an IOR of 0.8, 0.9, 1.1, and 1.2 respectively, and then a last rendering with an IOR that varies over the surface of the glass. The variable IOR was created with a pair of Gradient Ramp maps in the IOR channel of an Arch & Design (mi) material. When a map is used to set the IOR, white represents 1.0, and darker colors descend to lower IOR values.

DrinkingGlass.max

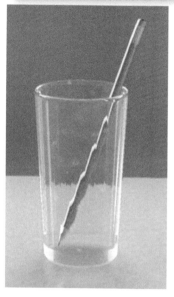
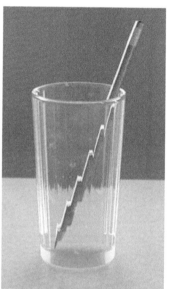
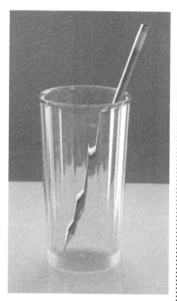

For many materials, 3ds Max provides a parameter to set the Index of Refraction for transparent/refractive objects. You can find the Index of Refraction parameter in the Extended Parameters rollout for Standard materials, and the IOR parameter in the Main Material Parameters rollout for Arch & Design (mi) materials.

There are numerous websites where you can find the real-life IOR for everyday items like glass, plastic, water, and gemstones. However, getting a realistic rendering isn't as simple as setting the IOR to the specified number. The IOR for glass clocks in at about 1.5, but the outside of a drinking glass might have a different IOR than the inside, and the glass might have imperfections. In other words, the physics-based IOR is just a guide. If the rendering looks good, the IOR is right; if it doesn't, it isn't.

Physics tells us that the IOR for all known substances is above 1.0. But the second and last renderings shown above, both of which use IORs under 1.0, are actually truer to the reference photo than those with IORs above 1.0.

So when you need to simulate refraction, go with what your eyes tell you, not with what the physics book says. A realistic rendering is always more "correct" than a technically accurate one.

■ Learning a few animation tricks of the trade will make it possible for you to animate scenes quickly and effectively.

7
Animation

ANIMATION IS WHERE the real fun comes in with 3ds Max. You can fly through or around your model or make objects whiz by. You can even animate materials and modifiers.

In this chapter, you'll learn how to utilize 3ds Max's powerful animation toolset to animate your scene in a minimum of time.

10.1016/B978-0-240-81433-9.50008-8

Animation 101

KEYFRAME ANIMATION is the easiest type to do with 3ds Max. Use this primer to learn the basic tools and start animating your scene right away.

1 A keyframe is a major point that the animation passes through. You don't animate every frame in 3ds Max; you just place the object at key points along the way, and 3ds Max figures out what to do in between.

4 While the time line shows you the keyframes for the currently selected object, you can see a full representation of all keys in Graph Editors > Track View - Dope Sheet. In Dope Sheet mode, Track View shows a track for each axis of each transform.

5 Curve Editor mode shows how the frames between keys are interpolated. To open this window, you can use the Mode menu on an open Dope Sheet or choose Graph Editors > Track View - Curve Editor. In Curve Editor mode, you can also move keys around to change timing, either in Track View or on the time line. Learning to use Track View and the time line effectively means you can create the animation you envision.

2 To create keyframes, turn on Auto Key at the bottom of the screen. Pull the time slider to go to a frame later than 0, and move or rotate the object. This sets a key at that frame and also at frame 0 if a key is not already present.

3 Move to other frames and transform the object again to set more keyframes. You can instantly see the results of your keyframing by pressing Play Animation at the lower right of the screen. Press the same button to stop playback.

HOT TIP

To determine rough timing for your animation, play it in your head while counting the seconds. This might sound silly, but it works. You can also use a stopwatch.

6 On the time line, right-click the key to see which parameters are animated at that frame. You can change the key value or frame number in the dialog that appears.

7 You can also animate any numeric parameter or color in 3ds Max by changing it with Auto Key turned on. Doing so creates a keyframe on the time line and in Track View.

8 You can set the total number of frames and the speed of the animation by clicking Time Configuration at the lower right of the screen.

Spinning your gears

WHEELS, GEARS, and other spinning objects often need to rotate over the length of the entire animation. With a few keyframes and a bit of math, you can get your wheels and gears in motion.

12 teeth 15 teeth

1 Draw a diagram to figure out how many teeth each gear will have. Numbers that divide evenly into 360 are easiest to work with. My gears will have 12 and 15 teeth.

4 On the NGon, select two adjacent vertices, skip two vertices, select the next two, skip the next two, continuing in this fashion all the way around the NGon.

5 Scale the selected vertices outward to form the gear teeth. Create the additional gears in the same way, selecting every other set of two vertices to form the teeth.

8 Turn on Auto Key. On a frame later than 0, such as frame 10, rotate each gear by the number of degrees equal to one tooth, which is 360 (the number of degrees in a circle) divided by the number of teeth. After rotation, the teeth will be aligned again. Scrub the animation to test it.

9 To make the gears turn infinitely, select one of the gears and open the Curve Editor. Select the Rotation track with the curve, and click the Parameter Curves Out-of-Range Types button on the Curve Editor toolbar. Click the right button under Relative Repeat, and close the dialog.

Gears.max

2 In 3ds Max, create an NGon shape for the first gear with four times as many sides as the number of teeth. Collapse the shape to an Editable Spline.

3 Select all vertices and right-click them to change them all to the Corner type. This will make it easier to form the teeth.

6 The additional gears should be proportional in size. For example, since the second gear has 20% more teeth (15 as opposed to 12), it should be 20% larger.

7 Prepare for animation by rotating and moving one of the gears so its teeth fit with the other gear.

HOT TIP

To rotate by exactly a specified number of degrees, type the value into the entry area at the bottom of the screen. If you're not sure which axis is correct, try each one. If you pick the wrong one, type in 0 to reset the rotation on that axis, and try again.

10 When you play the animation, you'll see a slight hesitation on each turn. Open the Curve Editor, select the points at each end of the animation curve, and click Set Tangents to Linear. When you play the animation again, the gear will turn smoothly.

11 Repeat the process for each gear, and play the animation to test it. Extrude the gears and shape them, and add additional elements as necessary to complete your scene.

Following a path

INSTEAD OF MANUALLY setting keyframes to animate an object, you can use a constraint. A constraint automatically animates an object according to specific parameters.

In this example, you'll use a Path Constraint to make an object follow a path shape over a series of frames. This technique is particularly useful for making a camera follow a path to create a fly-around or fly-through of your scene.

1 Create a camera in the scene at around the same spot you want it to be when the animation starts. Create a shape for the camera to follow, and move the shape so it starts roughly at the same spot where the camera currently sits. Here, I've created an Arc shape.

3 Scrub the time slider to see the animation. In the Motion panel, you can see that the % Along Path parameter in the Path Parameters rollout has been animated from 0 to 100 over the course of the total number of frames in your animation. If you want the object to start at the other end, you can turn on Auto Key and change the % Along Path parameter to start at 100 and end at 0.

2 Select the camera and choose Animation > Constraints > Path Constraint. A dotted line appears, waiting for you to select a path. Click the shape to complete the assignment of the constraint. The camera jumps to the start of the path.

HOT TIP

If moving the vertices causes the path to take a strange shape, change all vertices to the Smooth type on the right-click quad menu.

4 To change the path, you can convert the shape to an Editable Spline and move the vertices. The constrained object will move along the path in its new shape.

Look-a-here

THE LOOKAT CONSTRAINT is a rotation controller that forces an object to always be rotated to "look at" another object. In practice, this means that one axis of an object will always point toward another object.

The LookAt Constraint is particularly useful for controlling a pair of eyes. Instead of rotating the eyeballs manually to look this way and that, you can use a LookAt Constraint with a Dummy object to control the eyeball rotation.

1 Set up a couple of eyeballs to control. Here, we can make a little dog look this way and that with the LookAt Constraint.

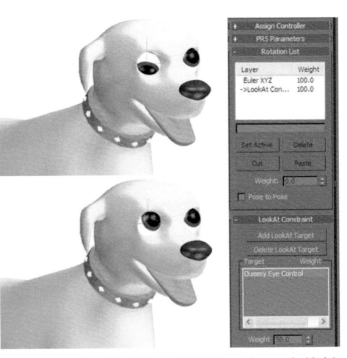

4 It's not unusual for the LookAt Constraint to deliver up the wrong LookAt Axis by default. Try different axes in the Select LookAt Axis group in the Motion panel to see which one works best. Here, the Y axis gives me the right result.

LookAtStart.max
LookAtFinish.max

2 Create a Dummy object for the eyes to look at with Create panel > Helpers > Dummy.

3 Select one of the eyeballs and choose Animation menu > Constraints > LookAt Constraint. Move the cursor to pick the object that you want the selected object to look at.

5 Repeat the process for the other eye. When you move the Dummy object around, the dog's eyeballs will automatically orient themselves to look at it.

7 Animation

Jumping beans

THE NOISE CONTROLLER animates an object randomly. This type of controller is useful for giving life to an object, making it sway or vibrate in a subtle way that will register as real to your audience. You can assign a Noise Controller to animate the position, rotation, or scale of an object, and adjust each one separately for that transform.

The animation produced by the Noise Controller appears to be random, but is actually calculated to appear that way. At the heart of the calculation is a Seed number that produces a motion graph. By using the same Seed for two Noise Controllers, you can produce exactly the same "random" effect today that you did yesterday. On the other hand, using a different Seed for two different objects gives you the same flavor of motion without an exact match in speed and direction.

Making the Seed values different is important; making them wildly different is not. Two consecutive Seed numbers produce completely different motion, so making the Seed 0 for one object and 1 for another will give you as much variation as using 57 and 2398 for the two values.

1 Select the object that you want to make jump around randomly. Choose Animation menu > Position Controllers > Noise. Scrub the time slider to see the object jump around.

3 Reduce the Frequency to make the object move slower. You will see the Characteristic Graph change to reflect the new frequency. Turn on the >0 checkbox for the Z Strength parameter to keep the object from moving below the surface it's sitting on. Adjust any other parameters as you like, and scrub the time slider to test the effect.

5 The Noise Controller takes over the definition of the object's position so you can't move it manually in the viewport. If you want to move the object to another location, select the Position XYZ layer in the Position List rollout to give control back to the default transform controller. Now you can move the object in the usual way.

Beans.max
JumpingBeans.max

2 On the Motion panel, expand the hierarchy in the Assign Controller rollout to see the Transform > Position > Noise Position entry. Highlight Noise Position, and right-click to choose Properties from the menu.

4 Repeat the process of assigning a Noise Controller to animate each object's position. Change the Seed parameter to change the graph pattern while retaining the same overall parameters. You can also assign a Noise Controller to an object's position with Animation menu > Rotation Controllers > Noise.

HOT TIP

Close the Noise Controller dialog before selecting another object. If you don't close the dialog and select another object, the dialog will still show the earlier object's parameters and not those of the currently selected object, making it too easy to accidentally change the earlier object and not the current one.

6 Add some motion blur by changing the object properties. Select all objects, right-click to choose Object Properties from the quad menu, and turn on the Image type of motion blur. After rendering a test, adjust the Multiplier value to give you the right amount of blur in the rendering.

165

Linktopia

LINKING OBJECTS TOGETHER with Select and Link can help you control your animation without having to animate each object individually. Linking works with a parent-child relationship, where you link the child to the parent and the child does what the parent does thereafter.

Dummy objects can assist greatly with linked animation. A Dummy object is a non-rendering Helper object that works as an intermediary between linked objects, allowing you to pass only movement and not rotation, or vice versa.

The advantage of linking to Dummy objects is that you can easily change the animation without losing your animation keys. Just link different objects to the Dummy objects to get a completely new animation.

In this topic, I've created low-poly models of icons of India to rotate around a traditional Indian carving.

5 Now you can rotate the center Dummy object to rotate the outside objects without rotating the center object.

6 To prevent the outside objects from rotating, select an outside Dummy and go to the Hierarchy panel. On the Link Info tab, under Inherit, turn off the Rotate checkboxes for X, Y, and Z. Repeat for each outside Dummy object.

IndiaLinks.max
IndiaDummies.max

HOT TIP

When linking, take care to drag the cursor to an area of the screen that contains only the parent to avoid linking to the wrong object. Click Select Objects to end the linking process and avoid linking additional objects by accident. You can also link by name by pressing the H key to select the parent object.

1 Use Select and Link to link all the outside objects to the one in the center, and rotate the center object. All the outside objects rotate around the center object and turn as they do so. If this is what you want, then you're done.

2 More likely, you'll want the outside objects to keep their original upright orientations as they rotate, and you won't necessarily want the center object to rotate. You can achieve this effect with Dummy objects.

3 Use Create panel > Helpers > Dummy to create a Dummy around the center object and around each outside object. Link each outside object to its Dummy.

4 Link all outside Dummy objects to the center Dummy. You can do this by selecting all the Dummy objects and linking them to the center Dummy at the same time.

8 To complete the controls, create another Dummy object around the center object, and link both the object and the first center Dummy to it. This will allow you to move or rotate both the center object and the entire assembly.

7 Now you can make the outer objects orbit the inner one without rotating.

167

Linking to multiple objects

LINKING IS A USEFUL TOOL for many types of scenes, but it limits an object to having one parent throughout the entire animation. For times when you want an object to follow one parent for a while and then another, use the Link Constraint.

In this example, the object follows two different parents, but in practice you could make an object follow numerous different parents over the course of the animation.

2 Animate the object changing position at the transition point. In this case, the nail jumps to the magnet when the magnet gets close.

MagnetStart.max
MagnetFinish.max

1 Select the object to be animated or the Dummy object that the object is linked to. Choose Animation menu > Transform Controllers > Link Constraint, and then click a stationary object in the scene. This will keep the selected object still until you want it to follow another object.

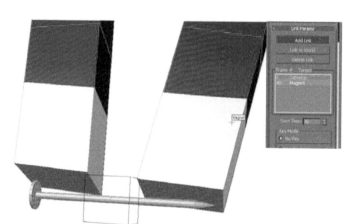

3 At the frame where the nail comes into contact with the magnet, go to the Motion panel and click Add Link, and pick the magnet.

4 Play the animation. The nail sits still until the magnet gets close, then jumps to the magnet and sticks to it as the magnet leaves the frame.

169

7 Animation
Chains

3 DS MAX INCLUDES a Bones system, a series of non-rendering objects that are already linked together. While Bones were primarily intended to create a skeletal system for a character, they are useful for animating a series of solid objects that need to stay together but move separately.

A series of linked objects is called a *chain*. Like a metal chain, each link can rotate on its own, but only as long as it stays connected to its adjacent chain members.

Any linked chain can be controlled by an IK solver. IK stands for inverse kinematics, a technical term meaning an individual link in the chain can be affected by links on either side of it. This is the opposite of forward kinematics, where a link can be affected by one end of the chain only.

Here, we'll use a short chain of five objects to illustrate the concept. In practice, you can use Bones and IK chains on as long a chain as you like.

On a historical note, the implementation of inverse kinematics in mainstream 3D software in the 1990s was a breakthrough that made all kinds of animation possible. A character animator, for example, could finally animate a leg by working with either the hip or the foot. Inverse kinematics is one of the reasons 3D animation has taken off so much in the past decade.

1 Create the chain as a series of objects laid out straight. While it isn't strictly necessary to have the objects lined up, it will make your work much easier if they are.

2 Choose Create panel > Systems > Bones to create a series of bones through the objects. Click at each joint in the chain to create a bone for that joint. Creating the bones at a slight angle to one another will determine the bend angle after you apply the IK solver. When you get to the end, right-click to create a nub at the end. Don't delete the nub.

3 Move the bones so they go through the objects, with each bone end coinciding with a "joint." In this case, the joints lie between the jewels. Use Select and Link on the toolbar to link each jewel to its bone. When you're done, click the Select Objects button or right-click the screen to close the linking process and avoid accidental linking when doing the next steps.

4 Now you'll apply an IK solver, a gizmo that allows you to use IK with your object. Select the first bone you created, choose Animation menu > IK Solvers > HI Solver, and click the nub at the end of the bone chain. This creates a new object, an IK Chain helper, between the nub and its previous bone.

5 You can move the IK Chain helper to change the shape of the chain, and can even animate it. To make this easier, you might want to place a Dummy object at each end of the chain, and link the first bone to one Dummy and the IK Chain object to the other. The object might flip onto its side when you do this, but you can simply rotate it back into place. If you want to change the angle of rotation of the chain, you can select the IK Chain object, and on the Motion panel, change the Swivel Angle parameter.

JewelLinks.max

HOT TIP

If the bones appear too skinny in your viewport, you can make them fatter by increasing the Width and Height values in the Bone Parameters rollout on the Modify panel. To change the parameters of multiple bones at once, go to Animation menu > Bone Tools and press Bone Edit Mode. Then you can change the parameters for several bones at once.

Animation

INTERLUDE

Super-duper tools

AS FASHIONS CHANGE, so do trends in 3D graphics tools. There are a number of features that came into fashion, had their heyday, and then faded into obscurity. Not entirely though, because they retain their positions on the menu release after release.

Old tools are never retired, because to remove them from the system would cause older files to cease working. Every production company that's been around for a few years has a library of these old files, and they are some of Autodesk's best customers.

This can confuse a new user. You want to become better at using 3ds Max, so you start perusing all the available tools. You read about them in the Help, and scratch your head. You try in vain to find someone who knows how it works. The problem is, those of us who lived through the tool's heyday discarded it from our personal toolset long ago, and we can't remember much about it except that it was replaced by something else.

The following tools are not worth learning about, except for historical purposes. I'm not saying you should never learn them, but if you're trying to get up to speed quickly on useful tools, you should skip over these features.

Video Post. Back in the old days, this tool was great for compositing scenes. With the widespread use of Photoshop, After Effects and Premiere, it's pretty antiquated. Still, you'll run into the occasional old file that uses it. Use the new Composite tool instead.

HD Solver. HD stands for history-dependent, meaning every time you update something it has to run through the entire animation to figure out what it's doing. This type of solver is good for mechanical animation that requires IK, but not for other applications. Use the HI Solver instead.

Spline IK Solver. This tool uses a spline to control a chain of objects. When it was first released, everyone got very excited about it. Then we discovered that if you curl the spline a certain way (as you're very likely to do in any animation of substance), the spline flips around erratically. Every 3D package with a similar tool has the same problem; it's rooted in the way IK works, and isn't likely to be solved anytime soon.

Scatter. Replaced by particle systems where you can pick the emitter.

BlobMesh. Gooey blobs you can stick together. Feel free to play with this one just for fun. It's hard not to be charmed by BlobMesh, but once you get above a small number of blobs, it's too slow to be useful.

Boolean. Replaced by ProBoolean.

NURBS. An alternative to polygon modeling, NURBS makes smoothly curved surfaces from splines. NURBS is useful for making curtains and tablecloths, and that's about it. Some industries use it almost exclusively, but if you're not in one of them (and you'll know if you are), learning NURBS is not the best use of your time.

Dynamics. An early attempt at physics. Use Reactor instead.

Physique modifier. Before the Skin modifier, it was all we had. Physique hasn't been updated in several releases, and the Skin modifier is now light years beyond it. If you need to update an old scene that uses Physique, your first order of business should be to replace Physique with Skin.

I'm sure that some people still use these tools; in fact, I expect to get angry emails from the three people who are still using Video Post. I'm not questioning anyone's right to use them. I'm just recommending that you learn the most useful tools first.

So then, you might ask, what tools should you learn? Why, the ones in this book, of course.

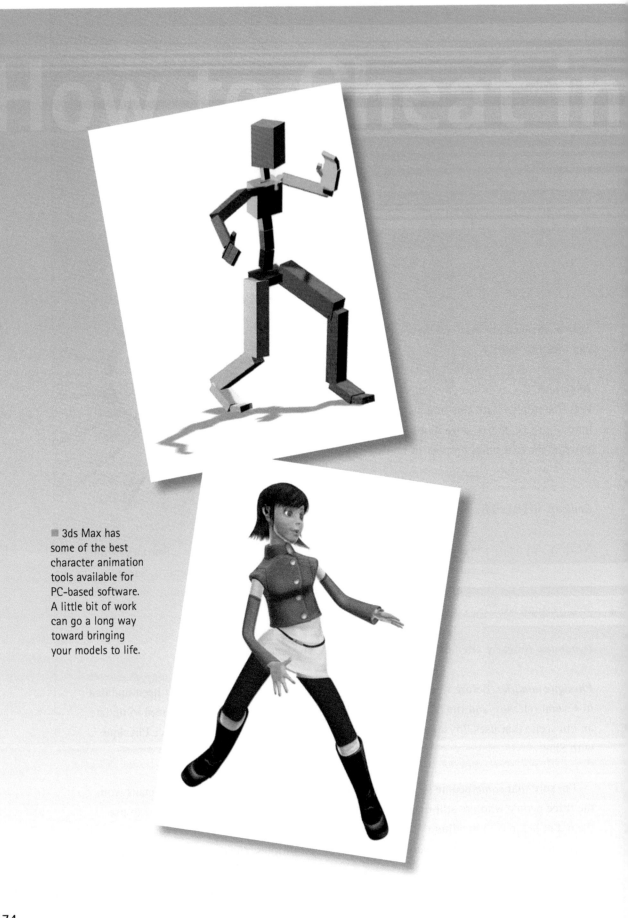

3ds Max has some of the best character animation tools available for PC-based software. A little bit of work can go a long way toward bringing your models to life.

8

Character animation

ANIMATION OF CHARACTERS is one of the primary uses for 3ds Max in the fields of games and broadcast. While this primer won't teach you everything you need to know to be a character animator, it can get you started with the main tools: CAT and Biped.

CAT is short for Character Animation Tools. CAT is a complete and easy-to-use animation system for creatures of all shapes and sizes. It used to be a separate plug-in, but CAT is now included in 3ds Max 2011.

Biped, an animation system designed for two-legged characters, is an older and less robust tool, but is still used by many animators.

10.1016/B978-0-240-81433-9.50009-X

Character animation workflow

S O YOU'VE HEARD about CAT and Biped and what they can do. How do you get started? The overview here will give you the basic workflow, and then you can use the topics that follow to kick-start your own project.

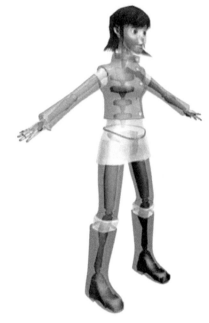

1 Start with a character model created with the usual modeling tools. Create a CAT or Biped skeleton and pose it to fit inside the character model.

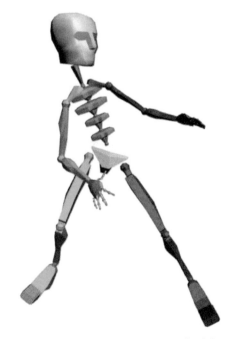

4 Once the skinning is complete, animate the skeleton performing the final animation.

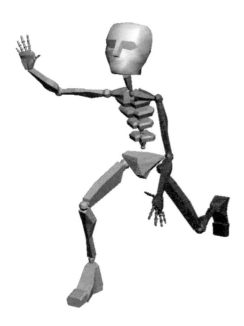

2 Create a short test animation for the skeleton, moving it through the poses it's likely to make over the course of your animation.

3 Use the Skin modifier to associate the skeleton with the character model, and adjust the influence of each bone over the vertices around it.

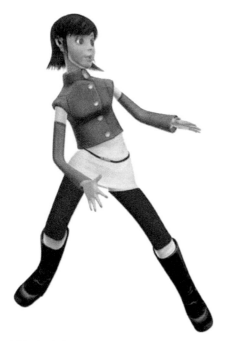

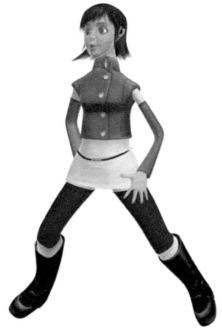

5 Hide the skeleton and check the animation. Adjust skinning as necessary, and render the final animation.

CAT 101

T HE CAT ANIMATION system is new in 3ds Max 2011. It provides a number of features including a wider variety of default skeletons and easy-to-use motion controls.

4 Before you start animating, click the Setup/ Animation Mode Toggle button in the Layer Manager rollout to change it to Animation Mode (green). This tells CAT that you're done posing the skeleton and you're ready to start animating.

5 Turn on Auto Key go to a frame later than 0, and start animating the skeleton. You can move or rotate just about any bone in the skeleton.

1 To create a CAT skeleton, use Create panel > Helpers > CAT Objects > CATParent. Choose a template in the CATRig Load Save rollout, then drag in a viewport to create the skeleton.

2 Fit the skeleton to the mesh, and skin the mesh. See the Skeleton Fitting topic for details on how to do this.

3 Select any part of the CAT rig, and go to Motion panel. In the Layer Manager rollout, click and hold the Add Layer button to display layer types, and choose Abs to add an Absolute Animation Layer.

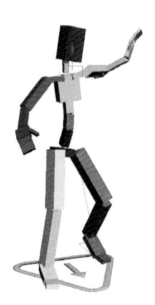

6 To move an entire foot, select the helper object underneath the foot and move the helper to move the whole foot.

7 To create a walk cycle, add a CATMotion Layer. This creates a default walk cycle that you can customize as you like.

8 To remove a layer's influence on a body part, select the part and lower the Local Weight value for that layer.

179

Biped 101

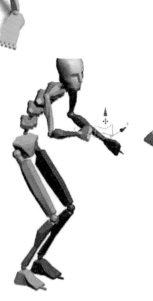

BIPED BODY PARTS work a little differently from regular 3ds Max objects. While you can animate as usual with Auto Key, several additional tools are available on the Motion panel that are specific to Biped tools.

To create a Biped, click Create panel > Systems > Biped, and drag anywhere in the scene.

3 Now you can turn on Auto Key, move to a frame other than 0, and start moving and rotating Biped parts. Don't animate the pose at frame 0. If you want the Biped to start off in a different pose, animate its parts into the pose on a later frame, such as 10. When you render, you can simply render from that frame forward.

4 To animate the entire Biped, move or rotate the COM (center of mass) object. You can select this object easily by clicking one of the first three selection buttons in the Selection Track rollout. The COM works a little differently from other 3ds Max objects, where it has a separate track for horizontal movement, vertical movement, and rotation.

1 One of the easiest ways to get an animation going with the Biped is to create footsteps for it. See the Walking in your Footsteps topic for details.

2 To prepare the Biped for a non-footstep-based animation (called Free Form in Biped parlance), you'll need to put a key at frame 0 for all Biped parts. Select all Biped parts, go to the Motion panel, and click the Set Key button in the Key Info dialog. You will also need to click each of the three COM selection buttons (the first three buttons in the Track Selection rollout) and click Set Key for each one.

In Track View, tracks for Biped parts are different from regular 3ds Max objects. There is one track for each entire leg/foot and one track for each arm/hand.

The COM object is named Bip01 by default. It's the root of the entire linked Biped hierarchy.

5 To move the entire animation, use Move All Mode in the Biped rollout. This causes a disk to appear around the COM, indicating that you can move or rotate the Biped to shift the entire animation. An Offset dialog appears where you can type in numerical values rather than manually moving or rotating the Biped. Be sure to turn off Move All Mode when you're finished with this tool.

6 To reuse a pose, copy and paste postures in the Copy/Paste rollout. First you will need to click the Create Collection button, and then select the Biped parts you want to copy and click Copy Posture. Then you can go to another frame, and with Auto Key turned on, paste the posture to the selected parts.

Character animation

Skeleton fitting

THE FIRST STEP in associating a skeleton with a character is posing the skeleton to fit the character. A skeleton that fits the character well will animate the character well. Conversely, it's nearly impossible to get a decent animation from a poorly fitted skeleton.

When you fit a Biped, you turn on Figure Mode in the Motion panel to indicate that you're posing the Biped and not animating it. With a CAT skeleton, you make sure the Setup/Animation Mode Toggle button is set to Setup (red) in the Motion panel. In general, you want the skeleton to fit inside the character model with its bones sized to about 1/2 to 3/4 the width of the model.

While working with a specific part of the skeleton, it's important to put on blinders and work with just that part to get it posed correctly before moving on to the next. The skeleton will look very strange until the very end, when it all comes together in a perfect pose.

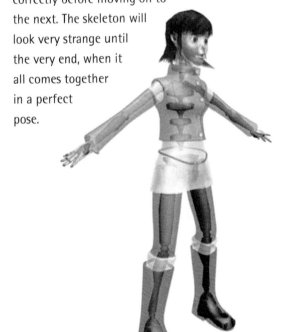

1 Your character model should be posed with its arms out at its sides and palms facing down, and with its feet a shoulder's width apart. It can also help to bend the arms and legs slightly.

5 Rotate and scale the skeleton's legs to fit the character's legs. If a CAT skeleton's legs don't go down the center of the character's legs, you can move the thighs to make them line up. For a Biped, you'll need to scale the Pelvis object horizontally until the legs fit. Be sure to match up the knees and ankles in all views, and rotate the legs slightly to match the bent legs.

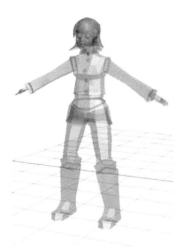

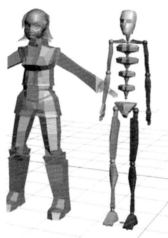

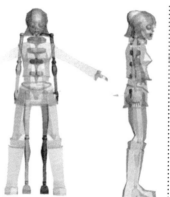

Girl.max
GirlPosed.max

2 Position the character on the ground plane grid. If you've applied a TurboSmooth modifier to the body, remove it. Make all the body parts see-through, and freeze them.

3 Create a CAT or Biped skeleton about the same height as the model. Set the skeleton parameters as necessary to match the type of character.

4 Move the skeleton to line up with the character body, and get the skeleton's hips in the same area as the character's hips. For a CAT skeleton, move the parent object and then the pelvis. For a Biped, go to the Motion panel and turn on Figure Mode, then move the COM (center of mass object) to the center of the character's hips.

HOT TIP

For the best results with skeletal fitting and animation, the character body model should be all one piece. While it's possible to use CAT or Biped with a multipiece model, the seams might be exposed when you animate the model. However, it's usually okay to leave the head and hair as separate objects.

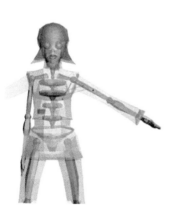

8 Fingers usually take the longest to pose. Scale the palm to fit the character, and move and rotate each base finger link to get it going in the right direction before scaling the finger links. The hand is easiest to pose in an angled view while simultaneously checking your work in an orthographic view. After you've done one hand, copy and paste the pose to the other side of the body.

6 Scale all the spine links to get the shoulders into the right place, then rotate the arms to fit the model. Be sure to check the Top view to ensure the skeleton's arms are inside the character's arms. Scale the skeleton's neck and head to fit the model.

7 Scale and adjust the feet and toes, making sure the skeleton's ankles fall at the model's ankles. If the character is wearing shoes or boots, the skeleton's feet should fill out the entire shoe area. Scale a single toe link to represent the entire toe of the shoe.

8 Character animation

Skinning

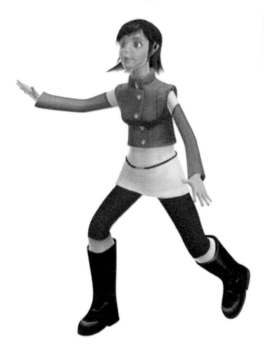

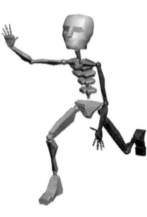

1 Hide the character model, and take the skeleton out of pose mode (for Biped, turn off Figure Mode; for CAT, add an Abs Layer and set the Setup/Animation Mode Toggle to Animation Mode). With the skeleton create a simple animation to test the skinning, such as bending the arms and legs. You should also create a Selection Set for the skeleton to make the skinning process easier.

SKINNING IS THE PROCESS of associating a character model with a skeleton. When you apply the Skin modifier to a model, it uses the bones you specify to determine how the model will deform when the skeleton is animated.

Skinning works by associating each bone with specific vertices on the model. If a vertex is affected by more than one bone, then the bone's influence on that vertex is determined by a weight value. All the weights for a vertex add up to 1.0, and a weight of 1.0 means the bone has complete influence over the vertex. Weights are set with the Abs. Effect parameter and the Weight Table.

4 Hide the skeleton. Pull the time slider to see if the character model deforms correctly. Chances are, it won't. The easiest areas to fix are the legs and arms. Let's use the left calf as an example.

7 Another area that's fairly easy to clean up initially is the torso. Select 2-3 rows of vertices and the nearest spine bone, and set Abs. Effect to 1.0. You can also scrub to a later frame to find and select vertices that aren't behaving correctly. Here, the vertices that make up the third button need to be affected by the second spine bone. At frame 10, they're easy to select and adjust.

MODEL BY TAN TECK WENG

184

2 TPut the skeleton back into its pose mode (turn on Figure Mode for Biped, or set Setup/Animation Mode Toggle to Setup Mode for CAT). Unhide just the character body. Remove any TurboSmooth or MeshSmooth modifier from the character, and collapse any modifiers still on the stack.

3 Apply the Skin modifier to the body model. Click the Add button next to Bones in the Parameters rollout, and choose all the skeleton parts.

SkinStart.max
SkinFinish.max

5 Select the body model. In the Parameters rollout, click Edit Envelopes. In the Select group, turn on the Vertices option. Select all vertices that should be affected by the left calf bone only. In the Parameters rollout, choose the left calf bone. In the Weight Properties group, change Abs. Effect to 1.0.

6 Scrub the time slider to a later frame, and check the left calf. Select individual vertices, and for each one, adjust the Abs. Effect parameter for the left calf and left thigh bones until the leg looks good. If you like, you can apply a TurboSmooth modifier above the Skin modifier to see how it's coming along.

HOT TIP

With straight skinning, as we've done here, elbows and knees don't retain their bony appearance when bent to extremes, giving you "spaghetti" or "noodle" arms and legs. To fix this problem, use the Skin Morph modifier to set custom volumes at extreme poses.

9 Work on the vertex weights until the entire body looks good in the test animation. Unhide the skeleton and the other body parts. Put the skeleton in pose mode again, and link any facial parts such as eyes, hair, and teeth to the skeleton head. Go into the skeleton's animation mode, remove the test animation keys from the skeleton, and your skinned model is ready for animation.

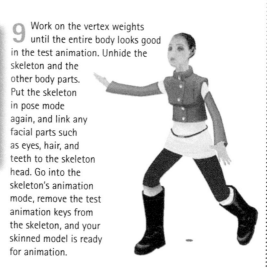

8 Once you've done a general cleanup, some areas, such as underarms and hips, will need additional work. Select a few vertices and open the Weight Table. Choose Selected Vertices at the bottom left of the dialog, and from the Options menu, choose Show Affected Bones. In the table, drag a weight value left or right to change the weight values. The vertex changes position as you change the values.

Walking in your footsteps

ONE OF THE BIPED'S key features is its
footstep tool, which lays down footstep
icons for the Biped to step through. This unique
feature uses a complex set of calculations to set
keys for the entire Biped skeleton, including the
spine and arms.

In order to use footsteps to animate the
Biped, you must not have set any keys for Biped
parts. If you animate one or more of the Biped
body parts manually, the Footstep Mode button
will be disabled, making it impossible to use
footsteps. If this happens, you can delete the
keys to make Footstep Mode become available.

1 Select any part of the Biped. On the Motion panel, turn
on Footstep Mode in the Biped rollout.

4 Click Create Keys for Inactive Footsteps in the Footstep
Operations rollout to create the keys. Play the animation
to see the Biped move through the footsteps. If more frames
are needed to create your animation, the length of the
animation is extended automatically.

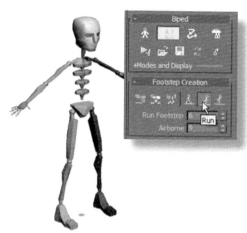

HOT TIP

If moving, rotating, scaling, or bending footsteps causes the Biped's legs to behave strangely (unexpected stomping, kicking, etc.), you can reset the body keys. Select the footsteps and click Deactivate Footsteps in the Footstep Operations rollout to remove the keys, then click Create Keys for Inactive Footsteps to reset them. While this will fix the leg animation, it will also remove any upper body animation, so copy the upper body animation to a track first and paste it back on afterward if necessary.

2 In the Footstep Creation rollout, choose a gait: Walk, Run, or Jump. The gait determines the overall footstep pattern that will be created.

3 Click Create Multiple Footsteps. In the dialog that appears, set the Number of Footsteps and other parameters as desired. Click OK to create the footstep icons in the scene. If you play the the animation, you won't see any action as the keys haven't been created yet.

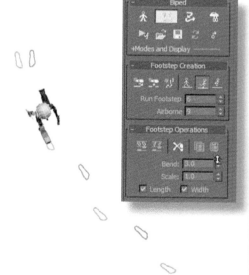

5 You can move and rotate the footsteps themselves, and the Biped's feet will follow them automatically. You can also use the Bend and Scale parameters in the Footstep Operations rollout to change selected footsteps.

6 To change footstep timing, open Track View – Dope Sheet while still in Footstep Mode, and expand the Bip01 Footsteps track. Each colored box corresponds to a footstep. Drag one end of a footstep key to change its length, or select and drag an entire key to move the entire footstep in time.

The alternative skeleton

SKELETONS COME in all shapes and sizes. The CAT system comes with a variety of default skeletons such as a centipede and alien. And while the Biped system is intended for two-legged creatures, you can use it to animate just about anything that's supposed to be alive.

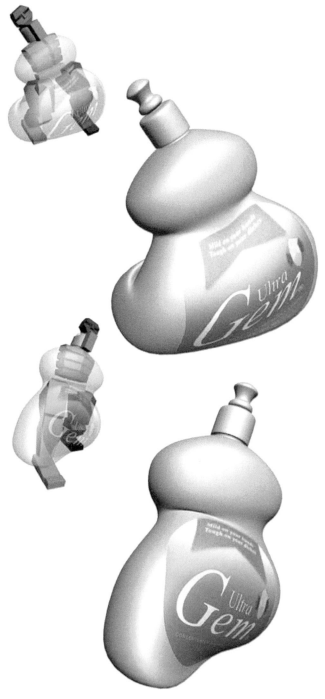

1 You can animate any household object with character animation tools. To do away with appendages that might get in the way, delete the arms from a CAT Base Human skeleton, or use a Biped with the Arms checkbox turned off.

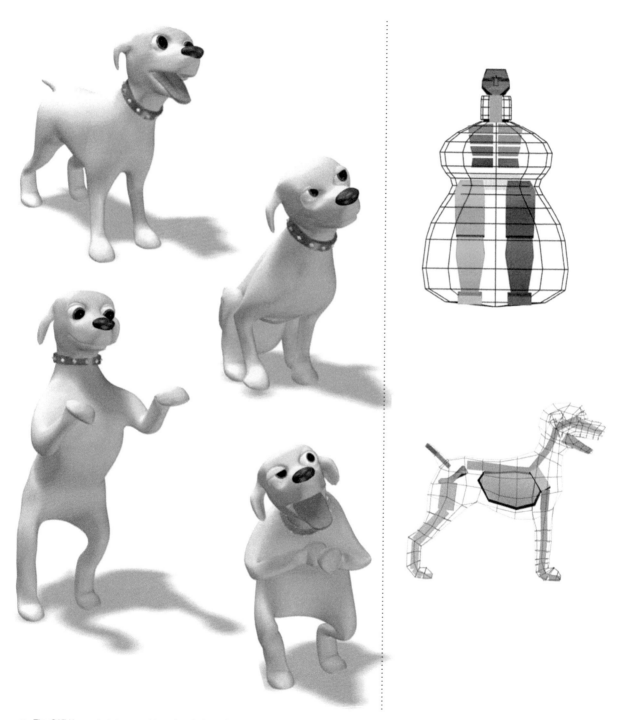

2 The CAT Horse skeleton provides a handy base for any four-legged creature. You can also make a Biped into a quadruped by bending its spine links over during the posing stage.

Bouncing and flexing

SECONDARY MOTION is action that occurs in addition to the main motion, often in a different direction. An example would be a horse's tail swishing and bouncing as it runs. The tail responds to the horse's motion by moving around on its own.

3ds Max has a few tools for simulating secondary motion without having to keyframe it manually. Here, I've used a simplified dog head to illustrate these methods. Each of these techniques makes the ear bounce and flex automatically as the head moves.

1 The Flex modifier is the simplest and fastest method for creating secondary motion. Apply Flex to a selection of vertices at the tip of the linked object, and it will stretch and sway automatically when the parent object is animated.

DogEarStudy.max

2 A Spring controller creates a virtual spring between two objects, in this case two bones in the ear. While the springy bounce is natural and realistic, it can take a very long time to compute if your animation is long.

3 A Reactor Rope provides a swingy path for the ear to follow with the PathDeform modifier. However, the result is inaccurate for extreme motion, as shown in the bottom image.

191

CAT vs. Biped

IN THE BEGINNING, 3ds Max had no built-in character animation systems. From 1990 to 1995, character animators using 3ds Max had to fend for themselves with Bones, morphing, and fairly primitive IK systems. While a few brave souls managed to get some good work done, the process took a long time and required an extensive knowledge of skeletal animation, not to mention 3ds Max itself.

Then, in 1996, a breakthrough. Unreal Pictures, an independent software developer, released the Character Studio plug-in for 3ds Max with its signature Biped skeleton. Although the first release was nowhere near as sophisticated as it is now, it did include those magic footsteps. Character animation suddenly became available to anyone willing to purchase the plug-in, and subsequent versions went from strength to strength. Character Studio, now known as Biped, was eventually included with 3ds Max when version 7.0 was released in 2004.

The same year, Character Animation Technologies introduced the Character Animation Toolkit (CAT) as a 3ds Max plug-in. CAT, with its superior toolset, was quickly adopted by production studios that specialize in advanced character animation.

Now that CAT is included with 3ds Max, you can expect that most new character animation projects will use CAT rather than Biped. However, there's still a long legacy of Biped animation out there, and chances are you'll have to deal with a Biped sooner or later.

The Skin modifier continues to be the tool of choice for skinning, but the original version of Biped included a modifier called Physique to perform this task. In its day, Physique was quite the slick tool, and it remains available in 3ds Max so old files that reference it will still open and function. However, Physique hasn't been updated in several versions, and the Skin modifier has long since surpassed it in ease of use, functionality, and reliability. From time

to time I run into someone who genuinely prefers Physique, but the vast majority of artists use the Skin modifier instead.

The same is likely to be true for Biped for many years to come. Artists who are very comfortable with Biped, and who find it meets their needs, will continue to use it for a long while.

If you're just now learning character animation, I advise you to go with CAT to keep your skills current, at least until the next big breakthrough comes along.

Cameras go hand-in-hand with rendering. Sometimes you just need to change a few camera parameters to get an illusion of depth.

9 Rendering

RENDERING IS THE EASIEST task in 3ds Max, in most cases just a matter of a few clicks. In this chapter, we'll look at ways to enhance your rendering experience while keeping the process fast and easy.

10.1016/B978-0-240-81433-9.50010-6

Rendering basics

THE RENDER SETUP DIALOG is your main resource for rendering settings. Choose Rendering menu > Render Setup to open the dialog.

While this dialog contains numerous parameters, there are a few that are crucial to creating the type of rendering you want.

1 To prepare for rendering, your first stop is the Time Output group in the Render Setup dialog. To render an animated sequence, choose Active Time Segment or enter a range of frames next to Range.

To render an
image for print
at the right
resolution,
multiply the
final size by the
desired dots-
per-inch (dpi) to
determine the
resolution. For
example, if the
final image will
be 3" x 4" at
300 dpi, render
the image at
900 x 1200. You
can use Render
menu > Print
Size Assistant to
help you with
this process.

2 Your next stop is the Output Size group. Choose from resolution presets, or enter a custom Width and Height.

3 If you're rendering an animated sequence, be sure to click Files in the Render Output group and enter a file name. Otherwise, your animation will get rendered to nowhere.

4 To accurately show what portion of a viewport will get rendered, click the viewport name and turn on the Show Safe Frames option.

Mental ray rendering

THE DEFAULT RENDERER for 3ds Max is called the Default Scanline Renderer. There are also two other renderers available: the Mental Ray renderer and the VUE File renderer. You will rarely use the VUE File renderer, but you will find many uses for the Mental Ray renderer, which creates images with a higher degree of realism than the Default Scanline renderer.

This topic gives you a quick guide to using Mental Ray. More information is available in the Materials and Mapping chapter and the Lighting chapter.

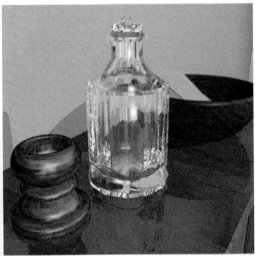

2 Under the Indirect Illumination rollout, turn on Enable Final Gather. Make sure the Preset is set to Draft.

3 To get the most from Mental Ray, change your materials to Mental Ray materials. See the Materials and Mapping chapter for specifics on how to do this.

1 To change the renderer to the Mental Ray renderer, click the pick button in the Assign Renderer rollout of the Render Setup dialog, and choose the Mental Ray Renderer from the dialog that appears.

HOT TIP

When you switch to the Mental Ray renderer, you might need to turn down the intensity of your lights by 50% or so to get the same general lighting you had before you switched the renderer. You can also use Exposure Control on the Rendering menu > Environment and Effects dialog to control the darkness or brightness of the rendering. Use the Preview window to get an idea of how your rendering will look.

4 Mental Ray renders one rectangular chunk (called a *bucket*) of the image at a time. The first pass is for advanced lighting calculations, and the second is for the final rendering.

Depth of field

T O MAKE A RENDERING look as much like a photograph as possible, the world of 3D borrows many techniques from photography. *Depth of field* is a photographic method for suggesting distance between objects by means of focus.

3ds Max has a built-in Depth of Field tool to make the process easy. Although it takes a bit longer to render, it's quick to set up and will give your renderings added realism.

3 Click the Preview button for the Multi-Pass effect. The planet will jiggle a few times in the camera view, and then will settle down to show you roughly how blurry the planet will be in the final rendering.

4 If the planet is too blurry, reduce the Sample Radius value. Here, I've reduced Total Passes to 10 and Sample Radius to 0.6. Click Preview again to see the result.

PlanetPlain.max
PlanetDepth.max

1 Load the file PlanetPlain.max and render the camera view. It's hard to tell how far the planet is from the satellite because both are in perfect focus.

2 Select the camera. Note that the camera target is aligned with the satellite. This means the Depth of Field tool will keep the satellite in focus and blur other scene objects. In the Modify panel, turn on Enable for the Multi-Pass Effect, and choose Depth of Field.

5 Render the scene. The Total Passes number determines how many passes the renderer makes before completing the rendering. On each pass, the scene becomes more visible.

A shift of perspective

THE PERSPECTIVE BUTTON changes the camera's field of view and its distance from the target at the same time. As a result, objects near the camera target retain the same size relative to the image, while other objects appear to move away from or come closer to the camera.

This tool is useful for quickly adding an air of drama to an otherwise static scene. When used in filmmaking, the cameraperson must carefully change the field of view (FOV) while the camera dollies toward or away from the subject. In 3ds Max, it's just a click-and-drag away.

1 Load the file Watch.max, which contains a watch surrounded by a spray of flowers. Play the animation. The watch hands go around over 300 frames. To give more depth to the scene, we'll use the Perspective tool on the camera.

3 Play the animation to see the effect. To enhance the feeling of movement, add a Depth of Field effect to the camera and animate the Sample Radius going from a small value to a larger one. As objects appear to move farther from the focal point, they will get blurrier as well.

Watch.max
WatchPersp.max

2 Go to the last frame and turn on Auto Key. Activate the camera view, and pick the Perspective tool at the lower right of the screen. Drag from the bottom of the camera view to the top to alter the FOV and camera distance at the same time.

Rendering large images

A THEATRICAL COMPANY asked me to produce a rendering of my ballroom to print on an 8'x8' backdrop. No problem, I responded.

Then I tried to render the image. Eight feet is 96 inches, and at 150 dpi, that means a resolution of 14400x14400. But 3ds Max flat-out refused to render the image at this resolution, claiming insufficient memory.

I decided to render the image in pieces, one region at a time, and then put it back together in Photoshop. So I started rendering regions. Besides being easy to mess up, this was extremely tedious. I realized that a script could do the work more quickly and accurately than I could do it myself.

I wrote the script, and a few hours later I was able to put the pieces together in Photoshop to make a perfect image for large-scale printing. The cast was thrilled to have such a fabulous backdrop, and I had a new tool for my toolbox.

If you can manage to split your image into just four pieces, you won't necessarily need to use a script. But if you have to do any more than that, I highly recommend giving this script a try.

. .

3 The main script line will render a portion of the image as a blowup to the full Output Size. Recall that we are rendering 25 images, so we'll need to divide 3000x3000 by 5, and thus render regions of 600x600. The upper left corner is at 0,0, so the lower right corner of the first region has to be at 599,599 to make a 600x600 image. Open the MAXScript Listener, and after making sure the viewport you want to render is active, type the following line (substituting the correct output size for the coordinates) and press Enter. The region at the upper left will render a blowup to your Output Size.

```
render rendertype:#blowup region:#(0,0,599,599)
```

4 Now you can write a script to deal with the entire image. Using a couple of for loops to increment the coordinates and the filename, you can make the script run through the entire image and render all the regions. In the script below, the output filename is also indicated, and the Rendered Frame window has been disabled during the rendering via the *vfb* command. Otherwise, you'd end up with 25 separate Rendered Frame windows on your screen.

```
increment = 600
filenum = 0
filenambase = "C:/Foldername/Imagename"

for j = 0 to 4 do (
  y = j * increment
  for i = 0 to 4 do (
    x = i * increment
    filenum += 1
    filenam = filenambase + (filenum as string) + ".jpg"
    render rendertype:#blowup region:#(x,y,x+increment-1,y+increment-1) outputfile:filenam vfb:false
  )
)
```

Pieces.ms

1 Decide on a final resolution for the rendering. Nice, round numbers are easiest to work with, and if the height is equal to the width, so much the better. Try to pick a number that can be divided evenly by 300 or 400. Even if the image ends up slightly larger than you need it, you can always crop it later in Photoshop. I chose to do my rendering at 15000x15000 to keep things simple.

2 Choose a size for the regions. All regions need to have the same dimensions for the script to work. Pick a size that your system can easily manage, but not so small that you have to render more than 50 regions to get the final result. I chose to render images at 3000x3000 for a 5x5 total of 25 images, but you might need to go smaller. Change the Output Size on the Render Setup dialog to the region size.

HOT TIP

Even if some parts of the image are plain black or white, render them anyway and use the pieces when putting the final image together. Having consecutive pieces to snap together makes the work much easier in Photoshop.

You can also get the same renderings using command-line rendering and the Split switch. To learn about this option, see the 3ds Max Help topic on Command-Line Rendering Switches.

5 In Photoshop, with snaps to Layers and Document Bounds turned on, you can snap the pieces together.

What is mental ray, anyway?

IN REAL LIFE, light bounces all around all the time. The light bouncing off any surface, such as your desk, and then into your eyes (so you can see it) might have bounced thousands of times before it got to you. Each time it bounces, it loses some of its energy (brightness).

To understand the effect this bounced light has on what you see in everyday life, take a look under your desk. You can clearly make out the carpet or floor below even though no light reaches this area directly. Light from a window or from overhead has bounced several times off the floor and the underside of the desk to illuminate this area enough for you to see it.

The Mental Ray renderer calculates an approximation of this bounced light. It isn't feasible for your humble computer system to calculate light rays bouncing as many times as they do in real life, so Mental Ray cheats a bit and uses just a handful of bounces. The reasoning is that by the time light has bounced a few times it's lost most of its brightness anyway, so you only need so many bounces to get a decent result.

Mental Ray renders by bouncing light around the scene a specific number of times. Compare with the Default Scanline Renderer, which does no such thing. The default renderer sends light rays out one time from each light source, and that's it.

In addition to lighting areas that don't receive direct light, bounced light also picks up a bit of color from each object it touches. For example, a brightly colored object near a plain wall will leave a subtle spray of color on the wall. This effect, called *radiosity*, makes the difference between a so-so rendering and a magnificent one. Viewers, without knowing anything about radiosity, will intuitively find a scene with this effect warmer and more inviting, not to mention more realistic. The Mental Ray renderer, when used with Mental Ray materials, produces this effect. To enhance the radiosity effect, increase the number of Diffuse Bounces in the Final Gather rollout to 1 or 2.

■ Two Mental Ray renderings. The image on the left has no Diffuse Bounces, while the image on the right has two. Note the red cast on the wall in the second image, where light bouncing off the red bottle affects the color of the wall.

Mental Ray includes two methods for bouncing light around a scene, Global Illumination (GI) and Final Gather. While the rays used for GI are narrower and give a more accurate result, Final Gather sends out big clumpy rays to light an entire blob of the rendering in one shot. Originally, Final Gather was intended to be used in addition to GI to lighten up dark corners and other areas that somehow didn't get their share of GI rays. But then artists discovered that you could get pretty good results with Final Gather alone, and that it was much faster to use than GI. The use of Final Gather alone has now become popular as a rendering workflow.

When using Final Gather, start with the Draft setting and make changes only as necessary. The Max Trace Depth value (Render Setup dialog > Renderer > Rendering Algorithms rollout > Reflections/Refractions group) determines how many bounces occur. By default this value is 6, and a rendering often looks pretty close to real with just 6 bounces. You can increase realism by increasing this value, but you'll also increase rendering time.

All this light-bouncing is done with an intense series of calculations on virtual rays rather than real rays. Thus the name Mental Ray.

■ Automate your animation with parameter wiring, and animate multiple objects by changing just one parameter.

10
Parameter wiring

TO SIMPLIFY the animation process, you can set up custom parameters that pertain to just the values you want to animate, and put all the new parameters in one central location. Then you can wire (connect) these custom parameters to real parameters to create a useful interface for your animation needs.

While programming experience and math skills are helpful for doing parameter wiring, they're not essential to take advantage of this powerful tool.

10.1016/B978-0-240-81433-9.50011-8

Wiring 101

T O ILLUSTRATE THE CONCEPTS of parameter wiring, I've used a simple animation of a bead on a wire. In this example, you'll create a custom manipulator right on the screen, and then use it to control the bead's animation.

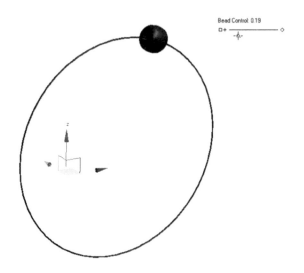

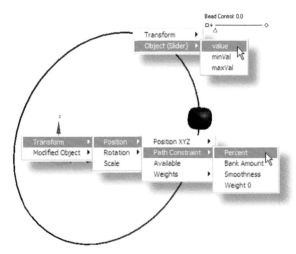

3 Now we'll create a custom manipulator to control the bead. On the Create panel, choose Helpers > Manipulators, and click Slider. Enter a name for the manipulator in the Label field, and click in the Front view to create the slider. Set Maximum to 1.0, and adjust the X Position and Y Position so you can see the slider on the screen.

4 Next, we'll wire the manipulator's Value parameter to the Percent parameter for the bead. Right-click the slider and choose Wire Parameters. From the pop-up menu that appears, choose Object (Slider) > Value. Click the bead, and from the pop-up menu, choose Transform > Position > Path Constraint > Percent.

1 Using the file BeadStart.max from the book's website, and select the bead. Choose Animation menu > Constraints > Path Constraint, and click the wire to put the bead on the path.

BeadStart.max
BeadFinish.max

2 Pull the time slider to see the animation. The bead goes around the path but doesn't turn with it. In the Motion panel, turn on Follow, and try different Axis settings until the bead goes around the wire correctly.

5 The Parameter Wiring dialog appears. Click the right arrow, and then click Connect to connect the two parameters together, with the slider controlling the bead's Percent parameter. Minimize the dialog.

HOT TIP

The reason we made the slider Value go from 0 to 1, rather than 0 to 100, is that 3ds Max internally stores the Percent parameter for the Path Constraint as a number between 0 and 1.

6 On the toolbar, click Select and Manipulate. Pull the slider handle to make the bead go around the wire. To animate the bead moving around a wire, simply turn on Auto Key and animate the slider value.

Bead Control: 0.19

211

Follow me

ONE BEAD is very nice, but what about multiple beads? We can't wire them all directly to the manipulator value or they'll all end up on top of one another. What we want is for each successive bead to follow the first, but with an offset so they'll follow in order.

1 Load the file BeadsSeq.max from the book's website. The first bead is wired to the manipulator, and is currently at the 0 position on the path. Select each of the other beads, and note their % Along Path values on the Motion panel. Each bead's percent differs from the previous one's by -4.0. This will translate to -0.04 with parameter wiring.

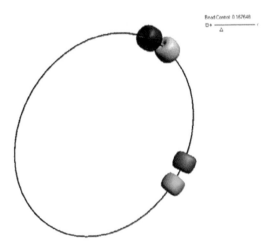

4 When you pull the slider handle, the second bead follows the first, always keeping a distance equivalent to 4% of the path length.

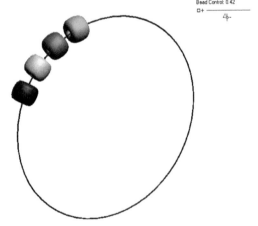

5 Wire the third bead to the second, and the fourth to the third, each time with an offset of -0.04. When you pull the manipulator handle, all the beads will follow along.

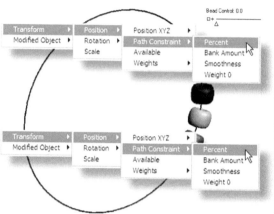

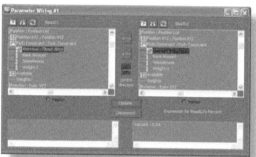

BeadsSeq.max
BeadsFollow.max

2 Select the first bead. Right-click it to choose Wire Parameters, and choose Transform > Position > Path Constraint > Percent. Click the second bead, and choose the same sequence of parameters.

3 In the Parameter Wiring dialog, the first bead appears on the left, and the second bead on the right. In the entry area at the bottom right of the dialog, change the entry to Percent – 0.04. Click the right arrow and Connect to make the connection.

HOT TIP

A manipulator is a special kind of helper that creates an in-viewport parameter control. Like every manipulator, you'll need to click Select and Manipulate on the toolbar before using it.

6 This type of setup works with any kind of path, even an open one. Here, I've converted the circle to an Editable Spline and used Break to break one of the vertices. Then I was able to fashion the spline into a necklace shape. When the first bead is at 0, the other beads will jump to the end of the path, as 3ds Max interprets a negative Percent value as 100 minus the value. For example, -4% is interpreted as 96%. To avoid this problem, you can adjust the slider's Minimum value to 0.12 to force the first bead to start far enough down the path to accommodate all the beads.

Parameter wiring
Telling time

YOU COULD SET THE TIME manually, but why bother when you can use wiring? Setting up wiring for rotation requires a smidgen of math and the use of a special function to convert the numbers to angular degrees that 3ds Max can interpret.

1 Load the file TimeStart.max from the book's website, and select the Dummy object at the top of the watch. This is the object that will hold our new custom parameters.

4 Rotate the hour hand Dummy with the Local coordinate system, and you can see that it rotates on the negative Z axis. You will use this axis when wiring it to the Hours parameter.

5 Select the main control Dummy, and wire its Object (Dummy) > Custom Attributes > Hours parameter to the hour hand Dummy's Transform > Rotation > Keyframe XYZ > Z Rotation parameter.

6 Since the watch face has 360 degrees and 12 hours, each hour is 30 degrees along the watch face. At the lower right of the Parameter Wiring dialog, type in – Hours * 30 (with the minus sign for the negative rotation), and click the right arrow and Connect.

TimeStart.max
TimeFinish.max

2 Choose Animation menu > Parameter Editor. Create a new parameter of the Float type called Hours, with a Range from 1 to 12. After you click Add, the parameter appears on the Modify panel. Create a second parameter called Minutes with a Range from 1 to 60.

3 We'll wire the hour hand first. But before we do that, we need to tell 3ds Max where the 0 position is. Select the hour hand Dummy and rotate the hour hand to point to the 12. Then use *alt*-right-click to display the animation quad menu, and choose Freeze Rotation. This resets the current rotation to 0 internally, so any rotation coming from wiring will start from that point as the 0 point.

7 When you adjust the Hours spinner, the hour hand goes wild. This happens because internally, 3ds Max expresses degrees as radians, an angular measure equal to about 57 degrees. You'll need to convert the degrees to radians with the degtorad function in the Parameter Wiring dialog. At the lower right of the dialog, change the entry to – degtorad(Hours * 30) and click Update. Adjust the Hours spinner to see the hour hand move smoothly from hour to hour.

8 Wire the Minutes value in the same way. Freeze the minute hand Dummy at the 12 mark on the watch face, check for the correct rotation axis, and use – degtorad(Minutes * 6) to wire the Minutes parameter to the minute hand Dummy's rotation parameter. Now you can animate the Hours and Minutes parameters as you like to set the time on the watch.

Spinning wheels

REMEMBER WHEN YOU dozed off in geometry class, wondering when you would ever use the stuff you were learning? That day has arrived.

In your animation travels, sooner or later you'll need to make something spin. Of course you can keyframe the rotation, but that can be tricky. If you rotate an object three full times, for example, 3ds Max will sometimes think the object just has to go the shortest distance between the start and end rotation, which is essentially zero. So keyframing rotations of more than 360 degrees can be troublesome.

Instead, look at wiring as an option. For example, suppose you need to animate a toy car moving along a road. You know how far the car is going to travel, so you can easily figure out the number of wheel rotations.

If you know a bit of geometry, that is. Let's revisit that musty old classroom and grab a useful equation or two.

A circle has 360 degrees, and a wheel turns 360 degrees to make one turn. So far, so good.

Every circular object has a radius, the distance from the center to the edge of the circle. If you know the radius you can figure out all kinds of things, like how much road a wheel covers when it turns one time.

Suppose you put a chalk mark on your car's tire, then roll it forward just far enough so the chalk mark goes around once and comes right back to where it started. You have just traveled a distance equal to the outside edge of your tire.

The measurement of this outside edge is called the circumference. To measure the circumference of a wheel, you can get out your tape measure and wrap it around the wheel. Or you can do it the easy way: measure the radius and make a calculation.

The circumference of any circle is the same as 2 times the radius times pi, a magic number equal to 3.14 something and a bit. Pi is sometimes represented as the Greek symbol π. You don't even have to know exactly what pi is to do your calculations. 3ds Max knows what it is, and that's all that matters.

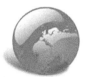

ToyCar.max

(D / C) x 360

D

R

C = 2 x R x pi

Say the car travels 300 units on the Y axis, and the radius of the wheel is 23. To figure out how many times the wheel turns, you need to divide the distance traveled (300) by the circumference of the wheel (2 x 23 x pi).

So that gives us the number of full turns. To get the number of degrees it has turned at any given time, just multiply the whole thing by 360, stick a degtorad in front of it, and you have wheels-a-turning. If you want to see this equation in action, you can find a toy car file on the website with all four wheels wired in this way.

Granted, this technique isn't for the faint of heart. But if you like the idea of automated animation, parameter wiring can't be beat. If that's the case, dust off that old geometry book and revisit those equations. All of them still work.

HOT TIP

To examine the parameter wiring in the ToyCar.max file, select the wheel. Choose Animation menu > Wire Parameters > Parameter Wiring Dialog. In the dialog, click the Find Next Parameter button until you find the Z Rotation parameter for the wheel. The equation appears in the bottom part of the dialog.

■ Natural phenomena and weather effects are created with a combination of special effects tools.

11

Special effects

ON ANY GIVEN DAY at the movie theater, you can enjoy a variety of special effects from rain, snow, and smoke to entire forests and landscapes.

While big-budget film effects might not be in your schedule, there are a few effects you can add to your scenes with a minimum of work.

10.1016/B978-0-240-81433-9.50012-X

Special effects

Cracks in a surface

ANIMATED CRACKS appearing in a landmass make a powerful visual statement. The ProBoolean tool with an animated loft makes quick work of it and allows you to determine where the crack appears and how fast it grows.

3 Next you'll animate the loft scale to make the loft grow along the path. Go to the Modify panel, and on the Deformations rollout, click Scale. In the Scale Deformation window, click Insert Corner Point, and add two points on the line. Click Move Control Point and arrange the graph as shown in the diagram. Use the value entries at the bottom of the window to enter the value 0 for the two rightmost points.

4 Go to the last frame of the animation, turn on Auto Key, and move the two middle points on the graph to arrange it as shown in the picture. Take care not to make the points pass by each other, as this could confuse 3ds Max and make it do unexpected things.

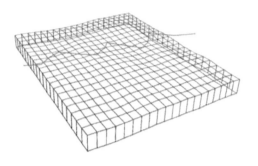

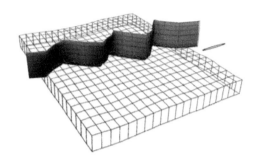

CrackStart.max
CrackFinish.max

1 Create a terrain with some thickness, and draw the line in the shape of the crack. Use Snaps Toggle with the Face option turned on. Create a line in the Top viewport starting outside the terrain, then zigzag it across the terrain to form the crack. Place three or four vertices between each twist and turn so the line stays on the surface the whole time. Be sure to turn off Snaps Toggle when you're done.

2 Create a tall, thin ellipse and loft it along the line. The resulting loft will be used to cut the crack. Make sure the Creation Method is set to Instance, and turn off Banking in the Skin Parameters rollout. Set Shape Steps to 2 or 3 and Path Steps to 0 for faster computation. If it looks like the cut won't be the right width or depth, change the ellipse parameters.

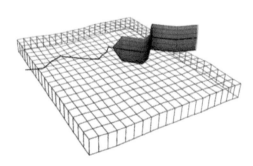

5 Test the animation by scrubbing the time slider. The loft should grow over time.

6 Select the terrain, and use the ProBoolean compound object to subtract the loft object. Hide the loft and scrub the animation. If you want to change the crack's path anywhere along the way, just move the vertices of the original line used to make the loft.

HOT TIP

To make the crack automatically have a material different from the surface, assign different material IDs to the surface and the loft before performing the boolean operation. You can do this quickly by applying a Material modifier with a different ID number to each object.

Rotoscoping

ROTOSCOPING IS the use of a previously filmed or animated sequence to create a finished scene. In the 3D world, this could mean using the sequence as a background or texture map. Another common use for rotoscoping is for putting an animated or filmed sequence on a TV or computer screen in the scene.

Basic rotoscoping consists of nothing more than using the sequence as a Diffuse map. Make it self-illuminated, add a glow, a bit of light, and you've got a realistic screen that looks as if it belongs in the scene.

The file you use to represent the filmed or animated sequence is referred to as a *clip*. If your sequence is already in MPG, AVI, or MOV format, you can use the file as the clip. If you want to use a series of still images, create a text file with the extension IFL, and list the files in sequence within the text file. In this case, the IFL file is the clip.

3 Turn on Show Standard Map in Viewport on the Material Editor dialog. When you scrub the animation (pull the time slider), the images on the TV screen will update in the viewport accordingly.

4 You'll need to give the screen a light glow to simulate a light source. To create the glow, use the technique described in the *Bright sunshiny day* topic in the *Lighting* chapter. Keep the glow Intensity low for a realistic look. Note that the glow appears only in renderings.

TVStart.max
TVFinish.max
TVClip.avi

HOT TIP

IFL stands for Image File List. You can generate an IFL file automatically with the IFL Manager utility (Utilities panel > More > IFL Manager).

In the Time Rollout for the animated bitmap, you can set the frame on which the animation will start.

1 Get together the images, animation, or film you want to show on the screen. You can use an MPG, AVI, or MOV file, or make a list of still images in an IFL text file. This file is your *clip*.

2 Create a material with the clip as the Diffuse map. Set the Self-Illumination value to 100 to make the images show brightly regardless of scene lighting. Assign the material to the screen.

5 Add a rectangular spot light pointing out from the screen to illuminate the area. Use a blurry, reversed version of the clip as a Projector Map to make light changes as the clip plays. You can also make the light a volume light. These effects are subtle but add a lot to the rendering.

6 When you render the animation, you'll see the series of images appear to play on the screen. If you want to add the clip's soundtrack to the rendering, you'll need to use the Sound track in Track View. Right-click Sound, pick Properties, click Choose Sound, and select the clip.

Raindrops

NATURAL PHENOMENA can be intimidating, especially water. All that transparency and refraction! But in reality, falling rain looks like a blur. Water droplets, when viewed en masse, are just reflective blobs.

To create an animation of raindrops falling on a window pane, you need rain outside the window, droplets fallling on a window pane, and a few drips for good measure.

Dreary lighting, a dark exterior, a reflective window pane, and dappled shadows on the window frame add to the gloom.

5 Create a material for the raindrops to make them look like water. No need to go overboard—a simple material with a Reflection map, lowered Opacity, and high shininess will do the job. Render a few frames late in the animation to see how the raindrops look with the material.

6 Copy the first raindrop to create two more raindrops. These will be your drips. Alter one of them to look like a long, dripping raindrop when viewed in the Top viewport. Select the round drip, and use the Morpher modifier to morph it into the long drip over 120-150 frames.

1 Set up the scene for rainy day lighting. Here, I've set up a dim direct light coming in through the window, and medium lighting in the room itself. A second direct light makes dappled shadows on the window frame.

2 Create a Spray particle system to spray particles outside the window. Turn on Object Motion Blur for the Spray in the Object Properties dialog. Adjust the particle Speed until the raindrops look like a fast blur in the rendering.

RainStart.max
RainFinish.max

3 Create a raindrop object to spread over the window pane. A sphere will do, but you'll catch more highlights with a flattened sphere. At the Vertex sub-object level, rotate the sphere so its flat end points down in the Front viewport. This will ensure the drops are oriented correctly when used with the PCloud particle system.

4 Create a plane over both window panes. Create a PCloud particle system, and choose the plane as the emitter. In the Particle Type rollout, choose Instanced Geometry, and pick the raindrop as the reference. Hide the plane, and set particle size and quantity values to get a nice spread of raindrops over the course of the animation.

HOT TIP

If you don't like the distribution of raindrops, you can get a new arrangement by clicking New under Uniqueness. This grabs a new Seed value for random calculations, redistributing the particles in a new configuration.

7 Create a second PCloud system for the drips, with the round drip as the instanced particle. The number of particles should be about 5% of the total number of raindrops. Under Animation Offset Keying, choose Birth to cause the drips to morph as soon as they appear.

8 Create a copy of the raindrop material, and add a Raytrace map in the Refraction slot for the drips. Because the drips are larger, you can detect the refraction in the rendering. There aren't a lot of drips, so the Raytrace map shouldn't cause a significant increase in render time..

In the jungle

DENSE FOLIAGE doesn't necessarily require tons of polygons. With the use of the Viewport Canvas and Object Paint tools and some clever maps, you can create a rich, thick, low-poly jungle so convincing that you'll find yourself scratching at imaginary mosquitoes.

1 Gather up textures for the jungle foliage, including matching opacity maps for leaves and fronds, and bump maps for tree textures. You'll also need a few images of dirt and leaves to mix up for the jungle floor.

3 Build low-poly trees and plants using your textures. You can use the same leaf textures to make different-colored leaves by varying their color channels in the Output rollout, or by adding a Color Correct map. For larger trees, apply a Noise modifier to the trunk to give it random bumps. Copy the trees around the scene to fill it in, rotating the leaf groups to vary the look of the plants.

4 A jungle scene needs dense foliage, but it isn't practical to fill in the entire scene with 3D objects. Instead, map an image of dense trees onto a cylinder placed around the scene. Make the material self-illuminated so it appears in renderings no matter what the lighting is. You can also fill in the ground area by scattering leaves around the jungle floor with the Object Paint tool from the Modifier ribbon.

Jungle.max

2 Create a ground plane for the jungle floor. After creating a material with a dirt texture, paint in debris with the Viewport Canvas tool. Create TIF images in Photoshop with the Pattern Generator, and copy them to the Custom Brushes folder. Access the Viewport Canvas tool from the Tools menu, select a custom brush, click the paint brush, select the plane, and paint the plane in any viewport. Add a Ripple modifier to the plane to give the ground some subtle height variations.

HOT TIP

The fastest way to open the Brush Images folder for the Viewport Canvas tool is to click the image slot under Brush Images to open the Viewport Canvas Brush Images dialog, then click Browse Custom Maps Dir. You can copy your custom brush images to this folder, and they'll automatically show up as Custom Maps in the dialog. Note that a custom brush must be saved as a TIF file to show up in the Viewport Canvas Brush Images dialog.

5 To simulate high noon sunlight, place a Direct light coming down through the trees. A bit of white Fog helps blur the edge of the plane where it meets the background cylinder. Make leaves closer to the camera slightly transparent and add a glow to them to make them look like real leaves being hit by sunlight. A Depth of Field effect on the camera blurs the far trees to match the background.

6 To enhance the streaming light effect, add a Volume Light effect to the Direct light. To make the light look as if it's shining through dense trees, you could add more trees to the scene, but you can get a better, faster effect by using a black-and-white map with the Direct light. Assign the map as a Projector Map in the light's Advanced Effects rollout.

Cigarette smoke

1 Set the number of frames to at least twice the length you actually need. This will enable you to pick and choose the section of the animation you want to use in your project.

4 In the Particle Generation rollout, set Emit Start to a negative number to put the particles in motion by frame 0. Set Display Until and Emit Stop to the frame count, and make Life long enough to show particles throughout the animation.

EVERYBODY KNOWS what smoke looks like in real life, so it should be easy to make in 3D, right? The challenge with smoke is its variable particle quality, changing from a solid-looking mass to thin wisps with the introduction of a mere puff of wind.

With smoke, as with any natural phenomenon, good reference material is the key. Smoke can have a different appearance depending on whether it's viewed from up close or far away, or if it's against a light or dark background. Be sure to find video or photographs of the kind of smoke you want to create, and use them liberally when setting up smoke for your own scenes.

7 Create a Wind space warp pointing in the direction of the particles, and bind the particles to it. Set Strength to 0 and Turbulence to a low number like 0.1. Experiment with different Scale, Phase, and Frequency values.

2 Create a SuperSpray particle system pointing in the direction you want the smoke to flow. Pull the time slider to see the particles. You'll need to increase the Off Axis Spread value in the Basic Parameters rollout. Here; I've set the Spread to 3.0.

3 In the Particle Type rollout, set the particle type to Facing in the Standard Particles group. In the Basic Parameters rollout, set the Viewport Display to Mesh so you can see the particles in the viewport. Facing particles always face the current view.

Cigarette.max

5 Set the Rate, Speed, and Size values to make the particles move at a speed appropriate for the kind of smoke you're making. All these values can be set in the Particle Generation rollout. Smaller particles at a higher Rate make finer smoke.

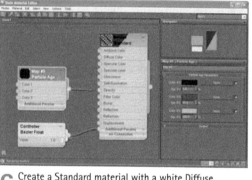

6 Create a Standard material with a white Diffuse color and a Particle Age map as the Opacity map. By graduating the Particle Age colors from black to gray over time, particles will become more opaque as they age.

8 Create a Drag space warp anywhere in the scene. Leave Unlimited Damping turned on, and select the Linear Damping method. Set the X Axis, Y Axis, and Z Axis values to a low number like 1.0 or 5.0. Bind the particles to the space warp, and experiment with values to get a curling effect.

9 To make the particles render like smooth smoke, use the Image type of Motion Blur for the smoke. You can turn on this setting in the Object Properties dialog. Set the Multiplier to a high value like 5.0 or 20.0, and do render tests to make sure the smoke is smooth.

HOT TIPS

The Wind space warp is used strictly to create turbulence for the Drag space warp to act on.

With particle systems, it's important to use a unit scale that makes your objects more than a few units in size. For the sample file, I decided that 1 unit is equivalent to 1mm, making the cigarette about 350 units long. This large number of units for scene objects allowed me to use reasonable settings for the particle system and its space warps.

Morphing

ONE OF THE MOST USEFUL tools for special effects is morphing, which turns one object into another over a series of frames. Morphing is accomplished by assigning the Morpher modifier to an object and picking target objects.

Morphing works by taking the vertices of one object and moving them to the locations of the other object's vertices. Under the hood, 3ds Max numbers the vertices of every object. When you morph one object to another, vertex #1 of the original object travels to the position of vertex #1 of the target object, vertex #2 in the original object travels to vertex #2 position of the target object, etc. The distance and direction in which the vertices travel are relative to the object's pivot point.

Morph targets have to have the same number of vertices as the original object, or the Morpher modifier won't let you use them. The best way to create morph targets is to make a copy of the original object and alter the copies to make targets. Then each target will have the same vertex configuration, with its pivot point in the same relative position to the final object.

Even with carefully made morph targets, things can go awry. Suppose you modify a morph target in such a way that the pivot point isn't really in the right spot. You can just move the pivot point, right? Wrong. Morphing uses the *original* pivot point location, no matter where you move the visible pivot point after the fact.

■ Raindrops from the Raindrops topic: round drop, long drip, and partial morph from round to long. The morph grows upward at the top due to the pivot point alignment. Moving the long drip downward at the vertex sub-object level will keep the pivot point at the right spot for a correct morph.

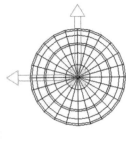
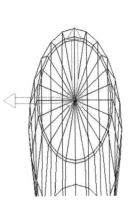
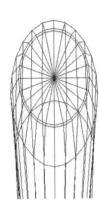

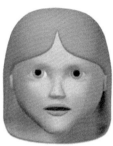

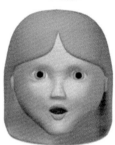

■ Morph targets for lip synch. For a full set of lip synch and facial expression targets, each major vowel and consonant sound is represented, as well as common facial expressions like blinking, smiling, and frowning.

The only solution is to move the entire object at the sub-object level to orient it to the original pivot point. This can get tricky, since the original pivot point is essentially invisible. The best approach is to align a helper with the pivot so you can see it when moving the object at the sub-object level.

Once you've created morph targets, there's no going back to the original object and collapsing vertices or adding edges. Such operations will cause a mismatch between the number of vertices in the original object and the morph targets. And you can't correct the problem by adding a vertex here and there. Doing so causes a change to the object's vertex numbering pattern. Remember that vertex #236 on the original object will travel to the location of vertex #236 on the target object. Adding vertices on one object changes its vertex configuration relative to other objects. This means that when you morph, you'll end up with a big mess, with the object turning inside out and most likely looking like a wadded-up tissue along the way.

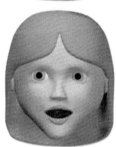

The most common uses for morphing are lip synch and facial animation. Create a series of morph targets representing vocal sounds and facial expressions, morph between them in time with the sound track, and you've got yourself a live, talking character. Just be sure to have the original object in perfect condition, with the exact number of polygons needed and all the vertices welded appropriately. Then you won't have the need to add or remove vertices after you've created the morph targets.

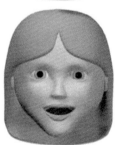

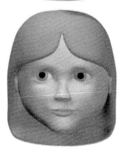

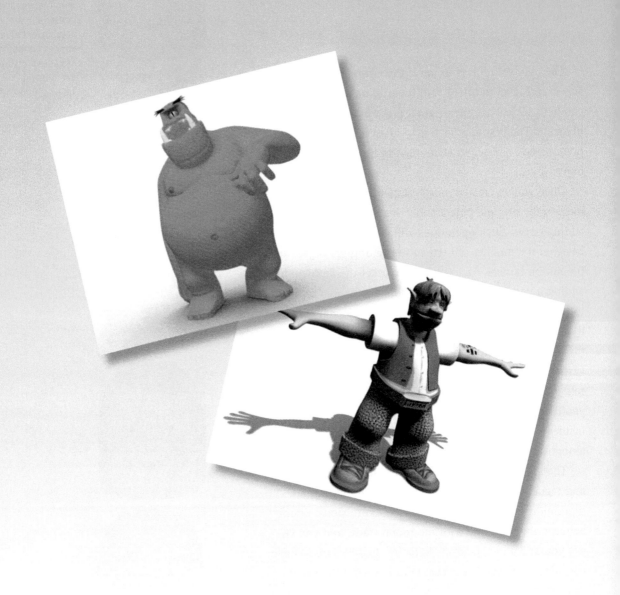

Appendix

HERE IN THE BACK, I've included some goodies to aid you on your journey to becoming a better and faster artist with 3ds Max.

These challenges will give you practice in the techniques described in this book. The Appendix also includes an alphabetical list of all files referenced in topics.

10.1016/B978-0-240-81433-9.50013-1

Appendix

Challenges

AFTER GOING THROUGH the topics in this book, you're probably eager to start putting the techniques to use. The challenges here are intended to inspire you to explore 3ds Max and create your own original works.

Use the images and guidelines provided here to practice the techniques in this book, or start with your own reference material.

CellPhone.jpg

1 Take a straight-on photo of a household object, such as a remote control or cell phone. Using the techniques described in the Modeling chapter, remove the perspective from the photo in Photoshop, and use the map both as a guide for modeling and as a texture. Make your own custom texture, or use the reference image on the book's website.

HandMirror.jpg

3 Model this hand mirror by drawing a spline outline and applying the Extrude modifier to it. Then model it by starting with a 10x20 Plane and moving vertices around and deleting polygons. Apply the TurboSmooth modifier to each model. Which looks best? You'll need techniques from the Modeling chapter, the Materials and Mapping chapter, and the Reflection chapter to do this one.

GrayBuilding.jpg

2 Start with a straight-on photo of a building. Flatten it out in Photoshop, and paint out items that hide the facade, such as trees and street elements. Use the photo to model a 15-minute building like the one in the Modeling chapter. Take a photo of a building in your environment, or use the image provided on the book's website. Then light the building's windows for both day and night as described in the Glass chapter.

VerdonRiver.jpg

PHOTO BY JAMES HUMBERD

4 Try your hand at making your own mountain. Create a tileable texture from a photo, then use it to draw splines that follow the shape of the texture. Use the technique described in the Modeling a Gorge topic, which can be found in the Modeling chapter.

Challenges

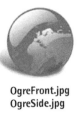

OgreFront.jpg
OgreSide.jpg

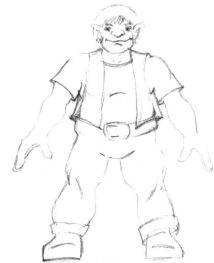

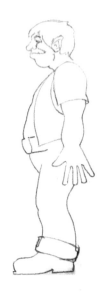

REFERENCE IMAGES AND MODEL BY JIM MALLARD

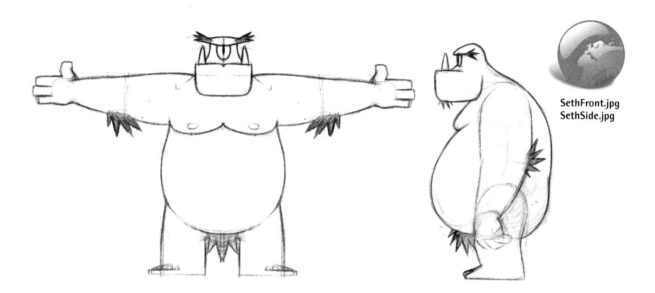

SethFront.jpg
SethSide.jpg

5 What's more fun than modeling characters? Nothing is, according to my students. That's why I've included these reference images so you can make your own. These models were created by students in my Low Polygon Character Modeling class at CGSociety.org. They have graciously allowed me to include their reference images on the book's website so you can enjoy the same pleasure. Use the techniques described in the Character Modeling chapter to create the body and head, then rig and animate with the Character Animation chapter.

REFERENCE IMAGES BY NICOLAS ZARZA AND PABLO MORENO
MODEL BY NICOLAS ZARZA

Challenges

6 Using the techniques in the Reflections chapter, make your own gemstones and jewelry. Start with a sketch or photo to guide the proportions. This kind of gift won't cost you a thing!

7 Practice creating splines by drawing your name as one continuous line, similar to the way you'd write your name with cursive handwriting. Before starting, be sure to check out the tips in the Secrets of the Spline topic in the Modeling chapter. Because you're going to loft the spline, you'll need to have all Smooth or Bezier type vertices and no Corner or Bezier Corner types. Next, loft a small circle along the spline, and animate your name writing on the screen. Use the technique described in the Cracks in a Surface topic in the Animation chapter to animate the loft. You can also try the Sweep modifier to create the same effect.

Spots3.jpg

9 Reference material is important for animation, too. Videotape a friend walking, getting as close to a straight side view as you can. Then animate the Biped walking the same way. The crazier your friend walks, the more fun you'll have.

8 To get a handle on the techniques of making curved glass, try your hand at this well-used pitcher. Feel free to use the spots texture I created for my drinking glass in the Glass chapter.

Website files

F OR THOSE WHO LIKE to surf the book's site for interesting files and then find them in the book, here is an alphabetical list of all the files referenced in topics.

Index

Printed and bound by CPI Group (UK) Ltd, Croydon, CR0 4YY

21/10/2024

01777057-0016